The Campus History Series

STATE UNIVERSITY
OF NEW YORK AT
BROCKPORT

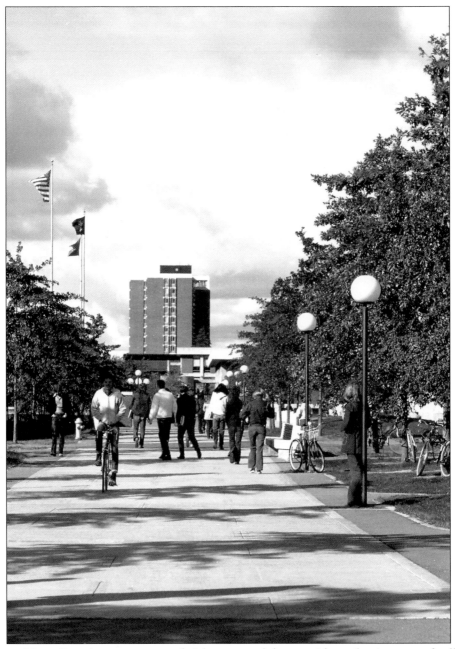

ON THE MALL. Crossing campus on a brisk autumnal day provides a classic scene of college life in western New York before winter blows down from Canada.

On the cover: **THE VIEW.** Generations of members of the Brockport college community have enjoyed this view, walking southward toward Hartwell Hall. For over a century, three successive buildings on this site housed the entire institution. Since World War II, the campus has moved westward, along an east–west mall anchored by Hartwell Hall. (Courtesy of State University of New York at Brockport.)

The Campus History Series

STATE UNIVERSITY OF NEW YORK AT BROCKPORT

MARY JO GIGLIOTTI, W. BRUCE LESLIE, AND KENNETH P. O'BRIEN

ARCADIA
PUBLISHING

Published by Arcadia Publishing
Charleston, South Carolina

Printed in the United States of America

Library of Congress Catalog Card Number: 2006929434

For all general information contact Arcadia Publishing at:
Telephone 843-853-2070
Fax 843-853-0044
E-mail sales@arcadiapublishing.com
For customer service and orders:
Toll-Free 1-888-313-2665

Visit us on the Internet at www.arcadiapublishing.com

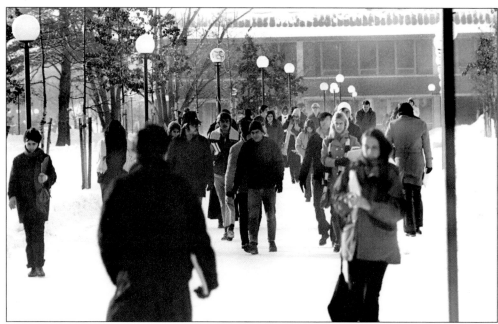
NOSTALGIA. In retrospect, even walking together stoically in the face of climactic adversity may rouse a little nostalgia in alumni.

CONTENTS

ACKNOWLEDGMENTS

Many friends and colleagues have generously contributed their expertise and time to making this book possible. Numerous Brockport students have added to our knowledge of the college's history over the last decade, contributing over 30 research papers, oral histories, and artifacts. A special heartfelt thanks is due to graduate student Deborah P. Wood for her ability and diligence with scanning images. She has been critical to the final stages of production.

We have benefited from the knowledge and publications of Brockport's resident local history expert, William Andrews. George and Rosie LaSorte Rich, Mindy Cater Wallington, Jacqueline Morris, Richard "Bud" Meade, and David G. Hale assisted in the details of local and college history. Many of our colleagues at the State University of New York at Brockport have lent their expertise and collegial support to the project, especially Richard Black. And we thank all those who have created and preserved the images we have reproduced here, especially Jim Dusen. Without them, the book could not have been written.

Former president Paul Yu, interim president John Clark, Pres. John Halstead, Provost Timothy Flanagan, and vice president for institutional advancement Roxanne Johnston provided critical institutional support and encouragement.

Most images have been drawn from the college archives of the State University of New York at Brockport. In addition, we have used the following published sources for information and images: William G. Andrews, *Early Brockport* and *Around Brockport*; W. Wayne Dedman, *Cherishing This Heritage*; John S. Jenkins, *Lives of the Governors*; Charlotte E. Martin, *The Story of Brockport for One-Hundred Years*; T. Morgan, *Virginia Union University What It Signifies*; *History of Monroe County*; Christine A. Ogren, *The American State Normal School: "An Instrument of Great Good"*; and State of New York, *The Erie Canal Centennial Celebration 1926*.

This book is dedicated to all members of the Brockport college community, past, present, and future.

INTRODUCTION

Launched as an Erie Canal village's improbable dream and then barely surviving several near-death experiences, today's flourishing college in Brockport would astonish those who built and sustained it through its first century. With breathtaking optimism and local pride, young communities across 19th-century America founded institutions of advanced learning. Many eventually perished, often leaving only picturesque buildings. But Brockport survived, and now thrives.

The Erie Canal reached Brockport in 1823. And while workers blasted through rock farther west, the fledgling village boomed as the canal's western terminus. Completion brought continued prosperity. By the mid-1830s, the trappings of respectability rubbed shoulders with the rough edges of a frontier community. When western New York's Baptists decided to found a college, village leaders enticed them to Brockport with a generous offer. Soon an impressive red sandstone building rose on a six-acre campus on the southwest edge of the village.

Barely enduring the panic of 1837, a fire, and the Civil War, the institution stabilized when New York State adopted it as a normal school in 1867, a status it retained until 1941. The designation of Brockport as a state teachers college, a status boldly etched above the entrance to its newly completed main building, marked the end of an era.

After briefly reviewing the first century (a story charmingly recounted more fully in W. Wayne Dedman's *Cherishing This Heritage*), this book turns to the college's modern history. World War II was a watershed. New York State's wartime decision that Brockport offer a specialization in health and physical education created a program that attracted an exceptional number of veterans. From 300 (almost all female) students in 1945, Brockport quadrupled in size and developed the full panoply of collegiate student activities by the early 1950s. The campus finally burst the boundaries of the six acres that had circumscribed it since 1835 to find space for dormitories and a student union.

Two New York governors abetted Brockport's further transformation. Thomas E. Dewey overcame considerable legislative resistance to establish the State University of New York (SUNY) in 1948. In the 1960s, Nelson Rockefeller decided to make public higher education one of his legacies at a time when the coming of age of the baby boomers made expansion imperative. Brockport president Albert W. Brown parlayed New York State's new generosity into unruly but dynamic growth. New faculty and programs energized the campus as construction transformed its appearance and enrollment soared to nearly 12,000. Brockport rose as a star within SUNY, portrayed in Alden Dunham's

Colleges of the Forgotten Americans as a model for teachers colleges morphing into multipurpose institutions.

Hosting the 1979 International Special Olympics climaxed this extraordinary period. Visited by celebrities such as Muhammad Ali, Rafer Johnson, and numerous Kennedys, and covered extensively on television, Brockport basked in national attention.

Behind this spectacular success, hard times loomed. In a difficult period throughout American higher education, Brockport suffered more than most. Total enrollment dropped by one-third, as the number of traditional-aged undergraduates plummeted. Fortunately "mature," commuting, and part-time undergraduate and graduate students saved the college from a worse fate. Faculty and staff rallied together to reduce the damage and sustain campus cohesion through two stressful decades. Incongruously, exceptional artistic and intellectual successes coexisted on the campus with periodic panics.

In the late 1990s, good times returned, with Brockport settling comfortably into the role of a respected comprehensive college—one serving many constituencies but with a renewed commitment to traditional college life. SUNY Brockport entered the new millennium with renewed reputation and confidence.

Enjoy this classically American story of a college founded as an expression of brash local pride and denominational aspiration, barely surviving its early decades and finally prospering through the generous support of its alumni, community, and state.

One

A CANAL, A VILLAGE, AND A COLLEGE
1835–1866

Without the Erie Canal, there would be no college in Brockport. The War of 1812 removed the British and Native American threat from western New York while demonstrating the region's continuing inaccessibility. Thomas Jefferson had derided a prewar proposal for a canal across New York as "little short of madness." When his successor, James Madison, vetoed the 1817 Bonus Bill containing provision for federal funding, New York was on its own. Financed first by New Yorkers and later by national and international investors, "Clinton's Ditch" slowly progressed from Albany to Buffalo.

In 1823, when the Erie Canal intersected a wagon trail that connected Leroy to Lake Ontario, it created a commercial center for a thriving agricultural area. Incorporated in 1829 and named after Heil Brockway, the largest landowner, the village of Brockport reverberated with the commercial rivalries, free-flowing alcohol, religious revivals, and voluntary associations of boomtown life. Two large reaper factories produced machines that harvested western New York's crops and temporarily made Brockport a manufacturing center. The New York Central Railroad's main line bypassed Brockport, preserving its village atmosphere but stunting industrial development. Instead, an educational institution would become the village's hallmark and later its growth engine.

As the flourishing canal port spawned a substantial village, affluent residents craved the civic institutions of middle-class American life. Good roads, churches, and schools were first steps, but a college promised prominence for Brockport. Fortunately the village leaders' aspirations intersected with those of New York's Baptists. Lacking an institution of higher education west of Colgate (then Madison) University, the Baptist Missionary Conference desired a presence in the heart of the "Burned Over District." Leroy and Warsaw, among other western New York villages, courted the Baptists. Brockport was the successful suitor, thanks to Heil Brockway's dowry of six acres and cash. Soon a Georgian building stood in the southwest corner of the village, and the fledgling college welcomed

its first students in September 1835. Like so many American colleges, local boosterism pollinated by Protestant denominationalism germinated an academic seed.

The odds for survival did not favor such an institution in a place just emerging from the frontier. Many towns created similarly ambitious educational enterprises but most, like Ingham University in nearby Leroy, withered away. Brockport itself barely survived. The first crisis came only two years later, when the depression of 1837 bankrupted both the Baptist Missionary Convention and the college, leaving an abandoned building. In 1841, a local syndicate purchased the building from the Baptists, who shifted their efforts to founding the University of Rochester, and established Brockport Collegiate Institute. It prospered until one Sunday morning in 1854 when a student who skipped church accidentally burned the institute to the ground. The religious meaning was as unclear as the temporal disaster was unmistakable.

Yet within months, an impressive Medina sandstone building rose from the ashes. Although local contributors subscribed much of the rebuilding fund, only a mortgage from the University of Rochester made completion possible. A successful educational enterprise required resources beyond those of a canal village in the age of the railroad. The Civil War diverted male students and local philanthropy, causing the Brockport Collegiate Institute to nearly drown in red ink. When New York State threw the struggling institution a lifeline, the trustees reached for it.

FATHER OF THE CANAL. De Witt Clinton's name is appropriately attached to the Erie Canal. He doggedly pushed the project from early planning through completion. After Pres. James Madison vetoed federal funding in 1817, Clinton skillfully organized a coalition, including former rival Martin Van Buren, that procured state support for the project. Derided by some as "Clinton's Folly," it eventually attracted national and international investment. "His" 363-mile canal was the longest in the world.

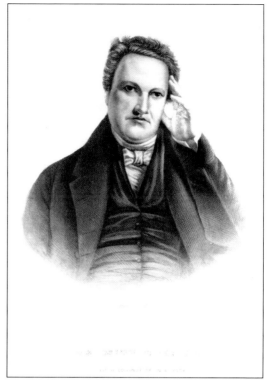

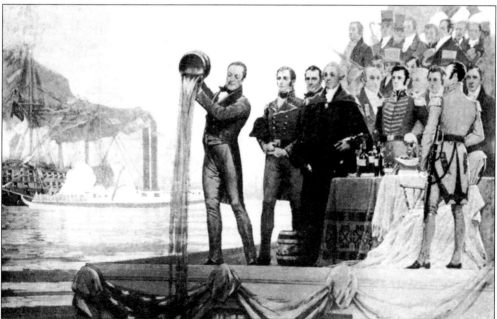

THE WEDDING OF THE WATERS. The completion of the canal in 1825 set off 10 days of celebrations. When Clinton rode the *Seneca Chief* from Lake Erie into the canal at Buffalo, a succession of cannons relayed the news to New York City 90 minutes later. The celebrations continued as Clinton's flotilla passed through Brockport and other canal towns to New York Harbor, where Clinton poured Lake Erie water into the Atlantic Ocean.

NAMESAKE AND DONOR. Heil Brockway, a Connecticut native, grasped the Erie Canal's commercial potential, speculating in land and starting businesses in Brockport before its completion. When the first boat arrived in 1823, he was poised to take advantage of the opportunities. A major boat builder, Brockway also operated the very successful Red Bird packet boat line. He immodestly arranged for the growing village to be named for him.

BOOMTOWN. The Erie Canal reduced the cost of shipping goods to New York City by as much as 95 percent. It also transported people inexpensively. Over 2 million immigrants passed through Brockport on their way west. Among the first passengers was the Marquis de Lafayette, who came through Brockport in 1825 on his heralded 50th anniversary tour, commemorated to this day by the village's Fayette Street.

REAPING THE BENEFITS. Famously, Cyrus McCormick designed the first reaper, transforming American agriculture. The problem of mass-producing his invention was solved in Brockport by the firm of Seymour, Morgan, and Roby, which produced the first 100 machines. Although McCormick moved his business to Chicago, Brockport remained an important reaper producer. William Seymour built a mansard-roofed house that served as the library for Brockport, Clarkson, and Hamlin from 1936 to 1996 and now houses the Village of Brockport's offices and the Emily Knapp Local History Museum. Dayton Morgan's Italianate mansion (below) is preserved as the Morgan-Manning House by the Western Monroe Historical Society.

13

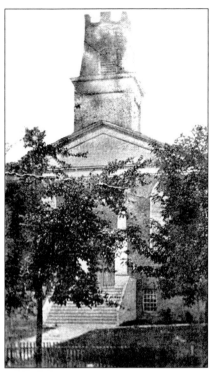

DENOMINATIONAL ENTHUSIASM. Evangelicals dubbed the Genesee Valley "the Burned Over District" due to the remarkable revivals sparked by Charles Finney just before the Second Great Awakening. Many of Brockport's churches date from this era, including this impressive early structure erected by Baptists in 1830. This building was replaced in the 1860s by the Baptist church that still graces Main Street. The region's religious reputation convinced New York's Baptists to establish a college in western New York.

A BAPTIST COLLEGE. Conceived through the cross-fertilization of denominationalism and local boosterism, a Baptist college opened its doors in 1835. Set on six acres donated by Heil Brockway, the four-story red sandstone building topped with a cupola must have been an imposing site. In October 1836, the Monroe Baptist Association optimistically resolved that "we contemplate the rising College at Brockport with great interest and pleasure" and urged their "brethren and friends of learning and religion" to support it. However, both the Baptist Missionary Convention and its college succumbed to the panic of 1837. Few records or images of the venture survive.

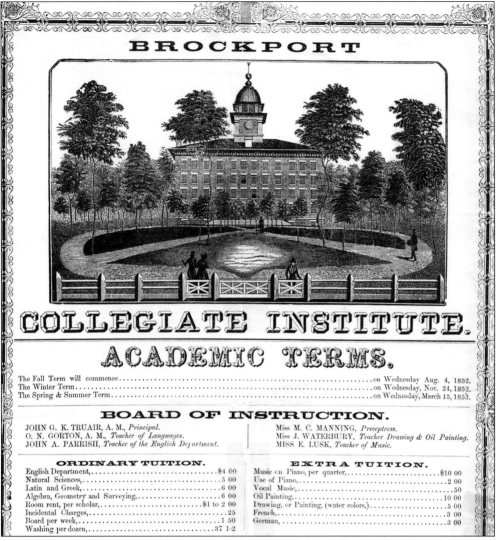

BROCKPORT

COLLEGIATE INSTITUTE.

ACADEMIC TERMS.

The Fall Term will commence...on Wednesday Aug. 4, 1852.
The Winter Term..on Wednesday, Nov. 24, 1852.
The Spring & Summer Term...on Wednesday, March 15, 1853.

BOARD OF INSTRUCTION.

JOHN G. K. TRUAIR, A. M., *Principal.*
O. N. GORTON, A. M., *Teacher of Languages.*
JOHN A. PARRISH, *Teacher of the English Department.*

Miss M. C. MANNING, *Preceptress.*
Miss J. WATERBURY, *Teacher Drawing & Oil Painting.*
MISS E. LUSK, *Teacher of Music.*

ORDINARY TUITION.

English Department,................................$4 00
Natural Sciences,..................................5 00
Latin and Greek,...................................6 00
Algebra, Geometry and Surveying,...................6 00
Room rent, per scholar,......................$1 to 2 00
Incidental Charges,.................................25
Board per week,....................................1 50
Washing per dozen,..............................37 1-2

EXTRA TUITION.

Music on Piano, per quarter,....................$10 00
Use of Piano,.......................................2 00
Vocal Music,..50
Oil Painting,.....................................10 00
Drawing, or Painting, (water colors,)..............5 00
French,..3 00
German,..3 00

THE SECOND TIME AROUND. The Baptist college's bankruptcy left an abandoned building and disappointed villagers. They soon rallied; 44 investors bought out the Baptist interest and prepared for another attempt. In December 1841, classes resumed in the Brockport Collegiate Institute with, the catalog bragged, "the most flattering prospects," and 130 students. The enterprise flourished educationally and local benefactors underwrote the perennial deficits. An announcement that a class to train teachers would "receive particular attention" foreshadowed what became the institution's hallmark. Although not church affiliated, its first catalog stipulated that "All students are required to attend church twice upon the Sabbath, unless specially excused." Brockport Collegiate Institute typified the 19th century academy. Financial support came from the local government, private contributions, tuition, and a little from New York State for teacher training. The curriculum was also a hybrid, ranging from elementary classes for young children to academic and professional training for older students. Note the variety of courses advertised in this 1852 prospectus including Latin, Greek, surveying, piano, painting, French, and German.

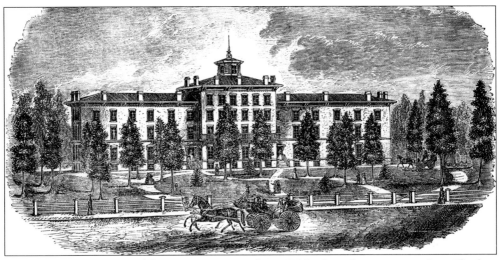

LIKE A PHOENIX. On Sunday morning, April 2, 1854, churchgoers were horrified to emerge and find the Brockport Collegiate Institute engulfed in flames. By afternoon, the building was a smoldering ruin. According to campus folklore, an errant student burned down the building when making candy instead of attending Sabbath services. Undaunted, the board of trustees assembled the next morning and pledged to rebuild. Ironically they had to turn to the University of Rochester, the next Baptist creation in western New York, for a critical loan to complete reconstruction. Another loan came from David Burbank, on the condition that he be appointed principal. Classes resumed in November 1855, and on December 23, 1856, a new and improved building that cost $30,000 and measured 200 feet across with 182 rooms was dedicated.

MACVICAR TO THE RESCUE. The debt incurred for reconstruction left the institute vulnerable to the vagaries of history. When the Civil War depleted the normal sources of students and philanthropy, the institute teetered on the edge of bankruptcy. Then the New York State legislature passed a resolution in 1866 to establish four normal schools to augment those in Albany and Oswego, Principal Malcolm MacVicar grasped the opportunity. Geneseo and Brockport competed to be the one awarded to the Rochester area. Brockport trumped its perennial rival by offering to deed the institute's building to the state and to raise another $60,000 to build two new wings. New York accepted Brockport's offer, as well as those from Cortland, Fredonia, and Potsdam. On March 21, 1867, the board of trustees finished its business and dissolved the institute, preparing for a new relationship with the state.

Two

BROCKPORT
NORMAL SCHOOL
1867–1941

In April 1865, classes resumed in the old Brockport Collegiate Institute building, reborn the next month as a New York State Normal and Training School. "Normal," unimpressive to Anglophone ears, translated poorly from its progenitor, the French *école normale*, a Napoleonic creation meaning a model of educational excellence.

The normal school's local supporters gladly accepted funds from New York State, while struggling to keep Albany at arm's length. They were more committed to saving their local institution than to teacher training. Thus, for the rest of 19th century, the institution continued to function as an "academy," serving as the local school system as well as providing an upgraded and enlarged teacher training program, essentially under local control. After 1900, the state education department intervened more forcefully, steadily narrowing the curriculum solely to teacher training.

The village's boomtown days had passed. With the New York Central Railroad's main line 10 miles to the south and the consequent decline in canal traffic and factory closures, Brockport's population peaked at just over 4,000 in the 1880s and then dropped below 3,000 by World War I, before recovering to about 3,600 by World War II. After the New York Board of Regents prohibited normal schools from providing on-campus housing in 1900, all students roomed in local homes. Thus, Brockport Normal School and the village remained mutually dependent even as power, like the Erie Canal's water, flowed toward Albany.

In the 1920s, the New York State Education Department stripped most remaining powers from its normal schools' local boards of visitors and ordered them to eliminate the high school classes from their campus schools. The 1934 dedication of a large red brick high school on a hill south of the normal school officially severed a fundamental town-gown link. But its proximity to the normal school laid the basis for today's adjacent campuses. Without the high school and with the most decrepit normal school building in

New York, the institution faced an uncertain future. As the Great Depression squeezed state budgets and the Brockport Board of Visitors squabbled over the appointment of a new principal, the New York State Education Department considered closing the school. Then, reversing direction, it appointed a vigorous new principal, Ernest Hartwell, former superintendent of schools in Buffalo.

Hartwell skillfully mobilized local, regional, and, eventually, state support, securing funds for a new building in the legislature's 1938 budget. Fatefully, to clinch the deal in the constrained budgetary atmosphere of the 1930s, Hartwell surrendered his plan to relocate outside the village to facilitate future expansion. When dedicated in June 1941, the Georgian structure topped with an elegant Williamsburg-style tower occupied the same six acres Heil Brockway had donated in 1834 on the edge of town, now encircled by houses on the east, north, and west, and railroad tracks on the south.

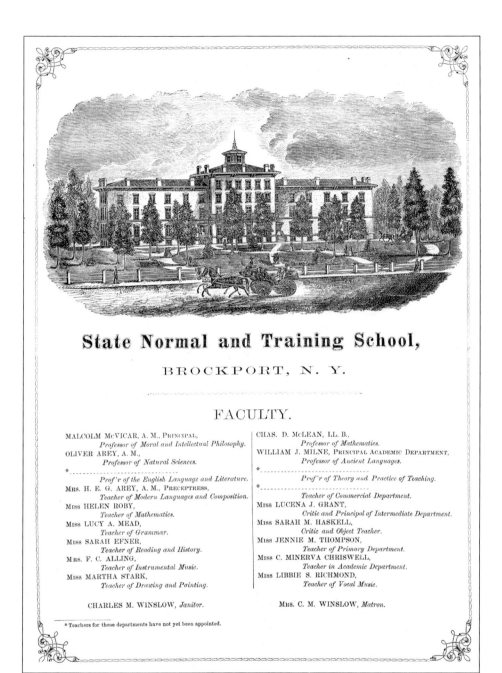

State Normal and Training School,

BROCKPORT, N. Y.

FACULTY.

MALCOLM McVICAR, A. M., PRINCIPAL,
Professor of Moral and Intellectual Philosophy.
OLIVER AREY, A. M.,
Professor of Natural Sciences.

* -
Prof'r of the English Language and Literature.
MRS. H. E. G. AREY, A. M., PRECEPTRESS,
Teacher of Modern Languages and Composition.
MISS HELEN ROBY,
Teacher of Mathematics.
MISS LUCY A. MEAD,
Teacher of Grammar.
MISS SARAH EFNER,
Teacher of Reading and History.
MRS. F. C. ALLING,
Teacher of Instrumental Music.
MISS MARTHA STARK,
Teacher of Drawing and Painting.

CHARLES D. McLEAN, LL. B.,
Professor of Mathematics.
WILLIAM J. MILNE, PRINCIPAL ACADEMIC DEPARTMENT,
Professor of Ancient Languages.

* -
Prof'r of Theory and Practice of Teaching.

* -
Teacher of Commercial Department.
MISS LUCENA J. GRANT,
Critic and Principal of Intermediate Department.
MISS SARAH M. HASKELL,
Critic and Object Teacher.
MISS JENNIE M. THOMPSON,
Teacher of Primary Department.
MISS C. MINERVA CHRISWELL,
Teacher in Academic Department.
MISS LIBBIE S. RICHMOND,
Teacher of Vocal Music.

CHARLES M. WINSLOW, *Janitor.*

MRS. C. M. WINSLOW, *Matron.*

* Teachers for these departments have not yet been appointed.

A NORMAL SCHOOL. In April 1867, New York's superintendent of instruction reported that, as Brockport had satisfied the legislature's stipulations, he was authorizing local officials "to open and put in operation immediately a Normal and Training School at said Village." Duly certified, Brockport Normal School began classes in the former Brockport Collegiate Institute building on April 17, 1867. Advertisements such as the one above attracted 140 students to the first year of the teacher training program, underwritten by a very welcome $4,034 from New York State. Malcolm MacVicar remained as principal, overseeing the expanded teacher training program as well as continuing the academic (also known as high school) and primary departments.

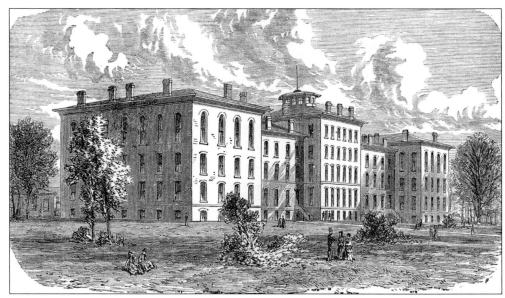

BIGGER AND BETTER. Selection to be one of New York's normal schools came at a high price. In addition to paying off the debt on the existing structure, the village promised to enlarge the building. After a bitter taxpayer revolt by those who resented subsidizing an "elite" institution, the funding was procured to add substantial north and south wings. The space was needed as the enrollment in the normal, academic, and primary departments soon soared to nearly 900.

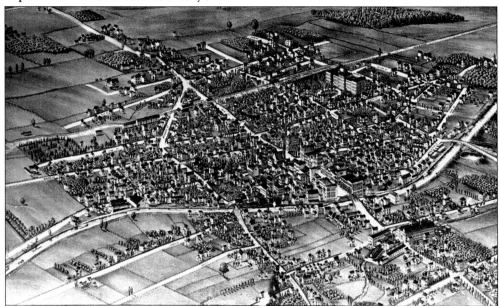

BIRD'S-EYE VIEW. This aerial drawing illustrates the village of Brockport at its industrial peak. In the foreground, factories line the Erie Canal. Churches, stores, and hotels dominate Main Street. The normal school sits magisterially on the southwest edge of the village, with the Niagara Falls branch of the New York Central Railroad line along its southern border. However, the main line had bypassed Brockport to the south, leading to industrial decline in the late 1800s.

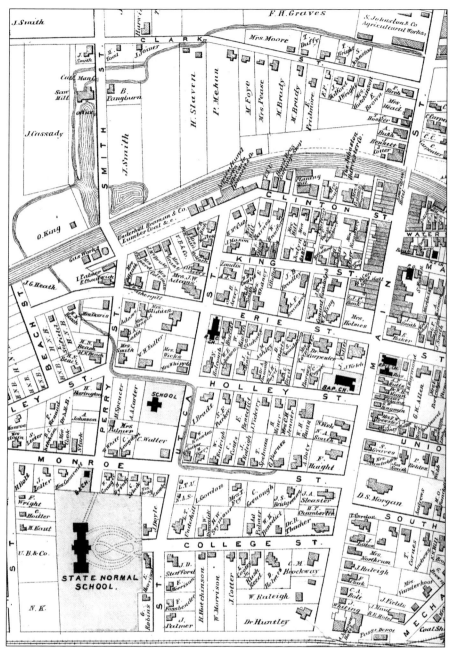

FROM ALBANY TO BROCKPORT. The citizens who paid the taxes to underwrite the generous offer that brought the state normal school to the village resided in a mature canal town of brick and clapboard houses. The canal and the New York Central Railroad spur line connected the village to Albany, but New York State's new commitment to the future college created the most enduring connection. By 1870, teacher training students were accompanied by nearly $20,000 in state funding. Although state funding saved the institution, most students continued to be enrolled in what effectively served as the local school system. Local trustees such as Daniel Holmes, whose house is visible on the south side of College Street, fought to maintain as much local control as possible.

THE HOMESTEAD

ON THE HILLSIDE

AND OTHER TALES.

BY
MRS. MARY J. HOLMES,
Author of "Tempest and Sunshine," "English Orphans," etc.

TO

MY FRIENDS IN BROCKPORT

THIS VOLUME IS

RESPECTFULLY DEDICATED

CULTURAL ICON. Daniel Holmes's wife was one of the most prolific and best-selling American novelists of the 19th century. Mary Jane Holmes's 38 novels, characterized by the *New York Times* as always "pure in tone and free from the sensational element," sold over two million copies. Her father-in-law was one of the Brockport Collegiate Institute's original trustees, and her husband served as secretary of the board of the institute and then the normal school for over 50 years. They moved into the Brown Cottage on College Street in 1861.

HOME OF PRESIDENTS. In 1898, the normal school purchased the Harrison House at the end of College Street and across the lawn from the entrance to the main building. Normal school presidents David Smith (1898–1901), Charles McFarlane (1901–1910), Alfred Thompson (1910–1936), Ernest Hartwell (1936–1944), and Donald Tower (1944–1964) all lived in the mansard-roofed mansion guarding the front entrance. The Brockport Alumni Association now calls it home.

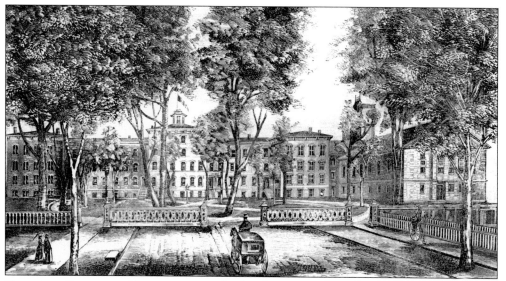

VICTORIAN SPLENDOR. The state normal school presented a splendid appearance at the end of the century. A school of practice (later called training school) had been added on the north end (right), housing 300 young pupils on whom future teachers rehearsed their chosen trade. Such laboratory schools for teacher training followed John Dewey's famous experiments at the University of Chicago.

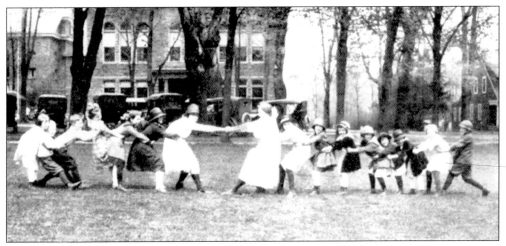

CRACK THE WHIP. Mimicking Winslow Homer's famous painting, pupils engage in a spirited tug-of-war in front of the training school.

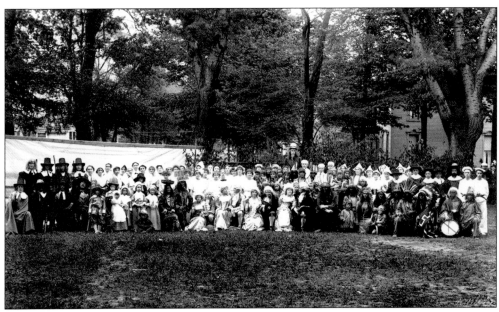

PILGRIMS. The training school pupils perform the obligatory costumed Thanksgiving play, no doubt assisted by the normal school's future teachers.

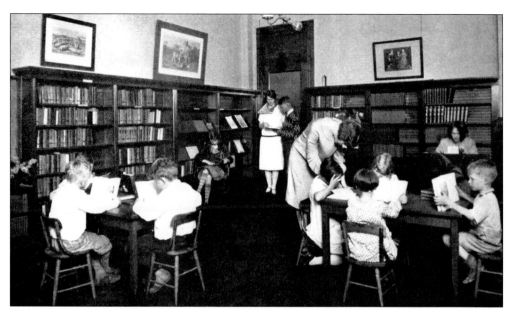

CHILDREN'S LITERATURE. The training school had its own library, devoted to children's books.

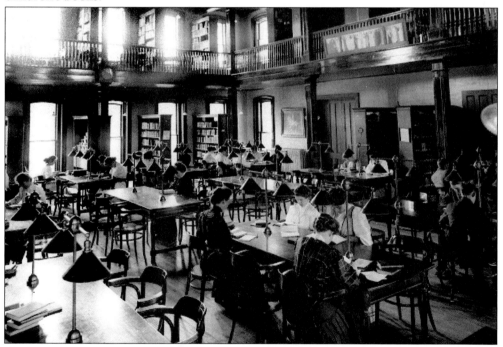

CONTENT VERSUS PEDAGOGY. Elimination of dormitory rooms in 1900 created space for this stylish library. The curriculum of these hardworking students was tilting strongly away from academic subjects toward pedagogical courses. Under pressure from the state, the academic department became a separate high school, housed in the normal school until 1934, and the old academy tradition of a rounded education withered. From 1907 until the early 1920s, the normal school offered only one- and two-year professional courses for high school graduates seeking teacher training.

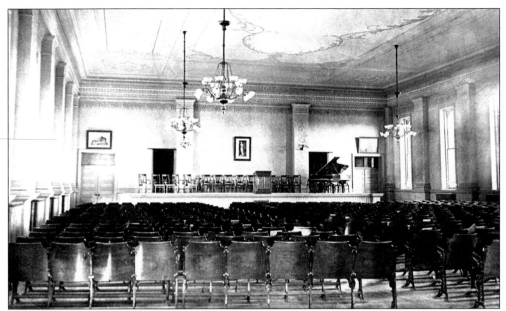

The Chapel. One floor above the training school, normal school students met daily in Normal Hall for assembly and spiritual reflection in the 1890s. After a further extension to the training school in 1901, this room became the first gymnasium, a conversion embodying the era's "muscular Christianity."

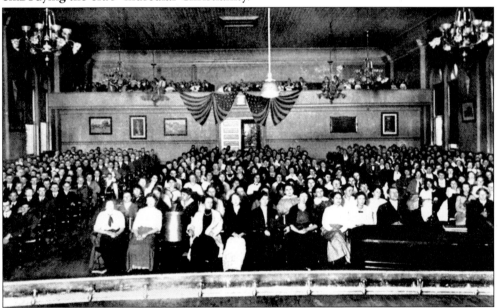

Assembled. Morning assemblies continued to provide a sense of community after the beginning of the 20th century in a new hall. Their resemblance to high school suggests the distinctive position of normal schools, defying categorizations as secondary education or higher education. Normal schools were in a class of their own. After 1900, Brockport Normal School required entering students to be high school graduates, but the curriculum was shortened to two years. Some graduates continued their studies with advanced standing in colleges.

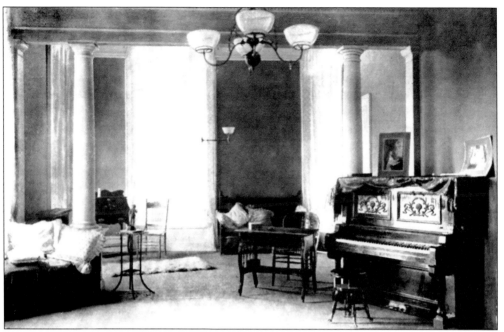

STUDENT SOCIETIES. Late-19th- and early-20th-century extracurricular activities centered around student literary societies with such imposing names as Alpha Delta, Agnonian, Arethusa, Philalthean, and Gamma Sigma. Activities included mock trials, travel reports, musical performances, presentation of research papers, and alumni visits. Social activities increasingly competed with the cultural, and the societies morphed into nationally affiliated sororities and fraternities.

BASKET BOARDING. After a fatal 1900 fire at Fredonia Normal School led the regents to ban on-campus living in New York's normal schools, all students roomed in local homes. This created a half-century tradition of "basket boarding," a term for living in Brockport homes during the week, going home on weekends, and then returning on Sunday evenings with baskets filled with a week's food.

27

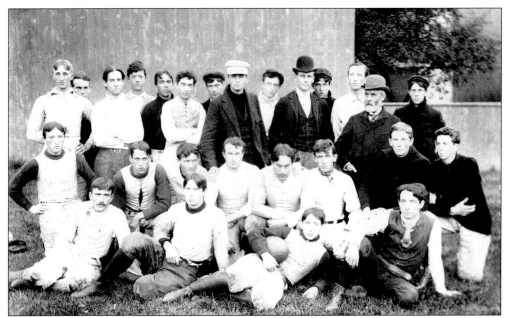

STILLBORN TRADITION. Low male enrollments repeatedly doomed the efforts to establish a football tradition. The normal school's second principal, Charles McLean, posing sternly in the third row, was a keen sportsman who promoted athletics. An Irish-born graduate of Brockport Collegiate Institute and the normal school's first professor of mathematics, he succeeded Malcolm MacVicar as principal in 1869 and served until 1898.

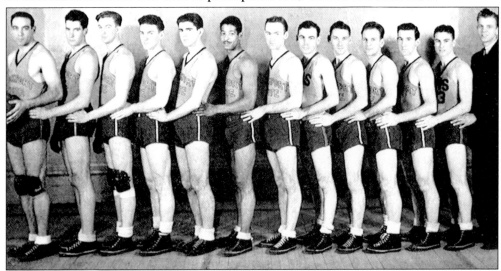

EARLY SPORTING TRADITIONS. It was easier to field a baseball or a basketball team, and most years they fielded teams that competed against other normal schools and regional high schools. After the high school students left the campus in 1934, men's teams became more collegiate. They dropped high schools from their schedules and adopted the tradition of awarding letters, the first awarded to these hoopsters in 1937. Basketball had the strongest tradition, and a game with alumni inspired the first reunions, the forerunner of today's homecoming. Nationally, intercollegiate competition for women fell out of favor, but intramural programs, especially basketball, thrived at Brockport.

ALL QUIET ON THE WESTERN FRONT. After World War I, memorial windows were installed in honor of the 101 Brockport students who served in the war and the five who sacrificed their lives. Thought lost, the windows were rediscovered in the 1990s and now illuminate the Kiefer Room in Drake Library. The students' service was also honored by planting 101 poplar trees along Utica Street, which edged the east side of the campus.

COLOR DAY. An enduring and much-loved tradition in its time, Color Day began in 1902 and became a spring ritual that lasted for 35 years. Student musical and theatrical performances were followed by outdoor festivities such as a maypole and folk dancing, a parade, and, finally, a dance attended by students and alumni. The increasingly raucous festivities offended school principal Ernest Hartwell, who abolished Color Day in 1937.

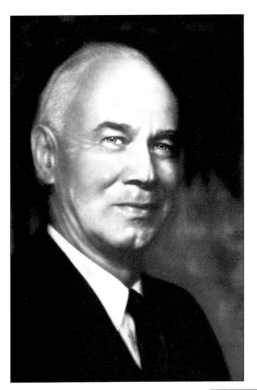

STERN SAVIOR. Ernest Hartwell's appointment in 1936 signaled that Brockport would not succumb to New York State's Depression-era budget woes. He skillfully mobilized local and regional support to procure a desperately needed new building and then effectively lobbied to convert the normal schools into state teachers colleges. A stern, even Puritanical taskmaster, Hartwell retired in 1944, leaving behind a transformed institution.

FACING THE FUTURE. With war looming on distant horizons, Brockport opened its door to the future as a state teachers college, a status proclaimed across the facade of its new building, appropriately later named Hartwell Hall. In the 1920s, the New York State Board of Regents restored the third year of studies to normal schools, and in 1934, it prescribed a more academically rigorous curriculum, foreshadowing conversion to collegiate status. The class of 1940 received normal school three-year diplomas, the last of over 70 classes to do so. There was no graduation in 1941, as the class of 1942's studies were extended another year to complete the four-year curriculum and receive Brockport's first baccalaureate degrees.

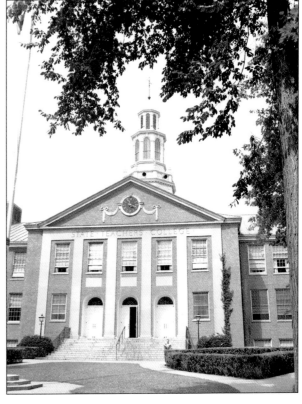

Three

A TEACHERS COLLEGE FOR THE EMPIRE STATE
WORLD WAR II–1965

World War II was a watershed for America. So too was it for Brockport. While war rumbled ominously across the Atlantic, Brockport was in transition. After three years of construction, dignitaries dedicated today's Hartwell Hall on June 4, 1941.

The words "State Teachers College" etched across the portico reflected Ernest Hartwell's determined optimism. New York lagged behind most states in converting its normal schools into state teachers colleges. Hartwell was a leader among those who successfully lobbied the legislature in 1939 to give college status to the upstate normal schools. But Gov. Herbert Lehman, pressured by downstate colleges, thrice vetoed the legislation. When he finally signed the bill in 1942, the governor inscribed into law what Hartwell had already set in concrete over the front entrance.

Then World War II put the college on hold. In the last wartime year, only 300 students attended. The graduating class of 1945 numbered only 61, six of them male. But within months of V-J Day, the campus began to grow dramatically. Once the Allied armed forces had turned the tide against fascism in Europe and the Pacific, planners in Washington and Albany had turned their thoughts to the postwar world. One proposal in New York's 1944 *Plan for Postwar Education in the State of New York* changed Brockport's destiny. The central mission of the recently designated state teacher college would remain training teachers for elementary schools. In addition, each college was assigned a specialty subject; Brockport, like Cortland, was to prepare New York's future health and physical education teachers.

The plan also projected that Brockport would grow slowly from 300 students to 500 by 1950. In reality, enrollments passed that mark in 1946 and reached 1,200 by 1950! That reflected a national underestimation of the desire for college education. Proponents of the 1944 GI Bill expected that only a few hundred thousand veterans would use it to pursue higher education; instead, more than 2 million did.

Such rapid growth was a mixed blessing for Brockport. New faculty were recruited for the health and physical education program as well as existing departments, doubling the teaching staff in five years. But facilities bulged at the seams. Military surplus Quonset huts arrived as emergency classrooms. To dismayed occupants, these temporary facilities remained in service until the mid-1960s.

While Brockport struggled with expansion, Gov. Thomas E. Dewey pushed a plan for a state university onto a resistant legislature. On April 4, 1948, with a stroke of his pen, the State University of New York (SUNY) was created, encompassing 32 state-supported institutions of higher education outside New York City and envisaging future medical schools and community colleges. Few could have imagined that the fledgling university, with fewer than 30,000 students and 2,500 faculty, was destined to become, arguably, the world's largest.

Post–World War II prosperity and the college's growth buoyed the village of Brockport, returning its population to that of the Victorian era. The departure of factories and warehouses from the center of the village left a picturesque Main Street. The village offered a comfortable home to many faculty, staff, and students and an ideal setting for a college community.

The 1950s brought stability. As veterans graduated, the student body returned primarily to the traditional age group. The college settled into a comfortable size. Little changed in the curriculum except for the creation of a part-time master of education program.

Then, in the late 1950s, the shock of Sputnik and the approaching baby boomer generation sent bulldozers into action again as the campus crept west and new faculty arrived to staff a proposed liberal arts program. By the time Donald Tower retired in 1964, enrollment had multiplied eight times in his 20-year presidency, and the transformed campus included a library, a science building, a gymnasium, dormitories, and a student union.

From the end of World War II until the mid-1960s, the years corresponding to Tower's presidency, Brockport epitomized the state teachers college announced to visitors approaching Hartwell Hall.

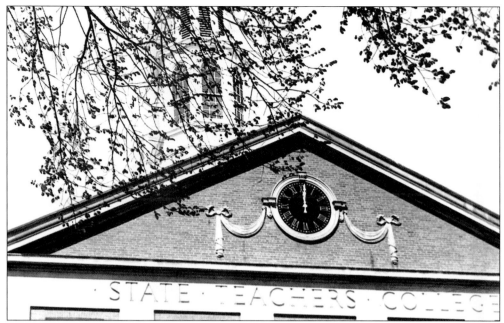

FINALLY A COLLEGE. More than a century after the first abortive attempt to create a college, Brockport could finally award college degrees. New York lagged behind most states in converting its three-year diploma–granting normal schools into four-year degree–granting colleges. The new building, completed in 1941, proclaimed the new status, and the next year, Brockport State Teachers College awarded its first degrees to the class of 1942.

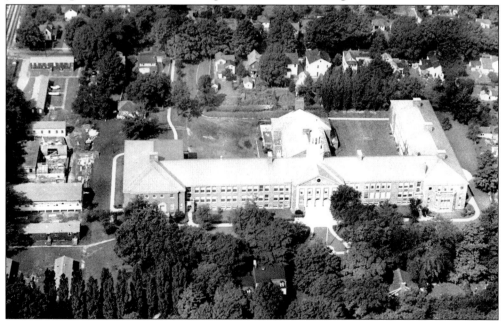

ONE-BUILDING CAMPUS. This aerial photograph reveals a postwar campus with one permanent building accompanied by temporary veterans' housing and incomplete Quonset hut classrooms along the railroad tracks to the south. The poplar trees planted in honor of Brockport's veterans of the previous world war stand in the lower left.

PASSING THE TORCH. Ernest Hartwell's short but productive tenure concluded in 1944, leaving a new building that would later be named for him and the transition to a four-year degree–granting college complete. His successor, Donald Tower (left), came to Brockport from Oswego, where he had been director of teacher training. A protégé of Herman Cooper, the powerful champion of state teachers colleges in Albany, Donald Tower's presidency was virtually synonymous with Brockport's years as a state teachers college.

THE TOWER MANNER. Although Ernest Hartwell had created the base for a new Brockport, he had left an institution bereft of tradition. President Tower brought a warmer personality to the office and a deep commitment to making the college a community, albeit a formal one. Even physical education professors coming from the playing fields had to don ties before collecting their mail. Yet the president could enjoy a good laugh.

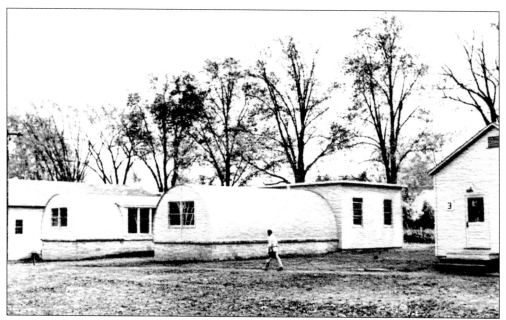

WARTIME SURPLUS CLASSROOMS. The exploding postwar enrollment and new faculty quickly outgrew Hartwell Hall. The temporary answer was Quonset huts, sent as military surplus from the Newport, Rhode Island, naval base. The anonymously named Buildings 1, 2, and 3 housed classrooms, laboratories, and offices for several departments. Their proximity to rumbling trains, attraction to passing birds, and extremes of temperature became legends passed on to later generations of faculty, including these authors, if they dared to complain about the relatively luxurious facilities of a later era.

THE 1940S HIGH TECH. The new building's library was soon overwhelmed by growing numbers of students and a new generation of faculty, many arriving with doctorates. This room served as the library until a separate building (now Rakov Center) was completed in 1961. Mary McCrory arrived as the sole librarian in 1932, and when she retired 30 years later, she oversaw a staff of 11. Studying was apparently a formal affair; note the jackets and ties. The library added its first microfilm machine in 1942. While this device gave students access to previously inaccessible materials, especially magazines and newspapers, the sight of these machines triggers memories of eye strain for generations of students and faculty.

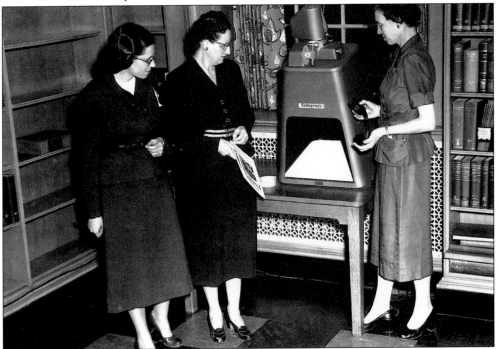

THE BIRTH OF SUNY. It was not an easy birth. In the 1940s, New York was the only state without a public system of higher education, and many private colleges and their supporters on the New York Board of Regents fought to keep it that way. But Gov. Thomas E. Dewey wanted to counter racial and religious discrimination at some private colleges and professional schools as well as have a higher education plank for his 1948 presidential election contest with Harry S. Truman. Despite opposition from some fellow Republicans, the legislation passed, and Dewey returned from the Wisconsin primary campaign to sign it.

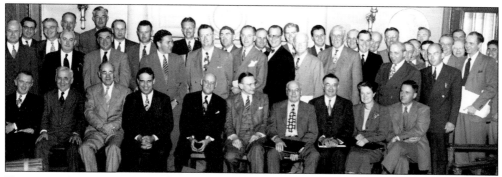

TOGETHER AT LAST. Even with Dewey's signature on the legislation, opponents in the legislature delayed implementation for another year. Finally, on April 5, 1949, Brockport president Donald Tower (standing second from the left in the second row) joined the leaders from the other 31 institutions in Albany to formally launch SUNY. Brockport's fate was now hitched to what eventually became the country's largest system of higher education.

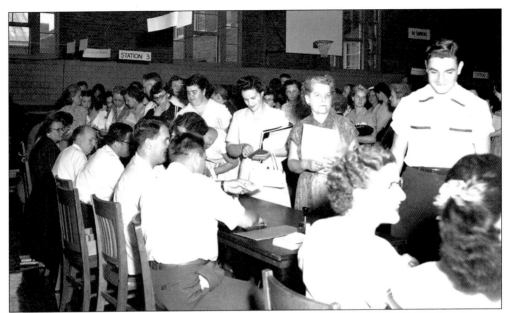

TIME-HONORED, UNLOVED TRADITIONS. Few alumni miss the ever-popular ritual of registering for classes. Even in the relatively small college of 1953 the process looks chaotic. The lock-step curriculum leading to certification did not leave a lot of room for choice, but fulfilling all requirements could be tricky. Another necessary evil of student life is purchasing the instruments of torture chosen by the faculty to keep them out of trouble. Note the mechanical pencils and inevitable stuffed animals. The manual cash register and L&M filter tip cigarette advertisement reminds one of a different era.

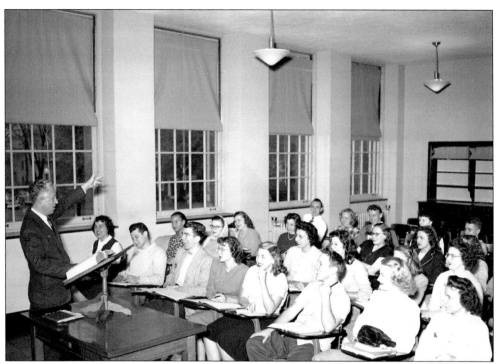

MAKING HISTORY FUN. Popular lecturer William Edwards has the students in the palm of his hand. He chaired the social science department from 1941 to 1959 and hired a core of young faculty, including the young historians looking at the map. Wayne Dedman, standing in the center, later authored the college's history, *Cherishing This Heritage.*

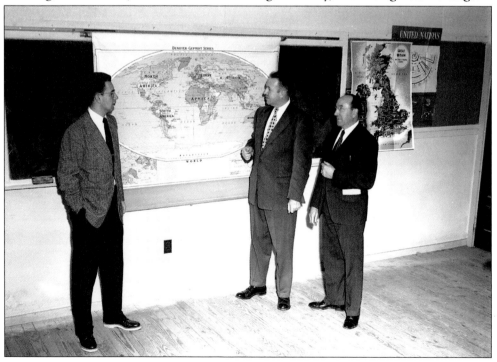

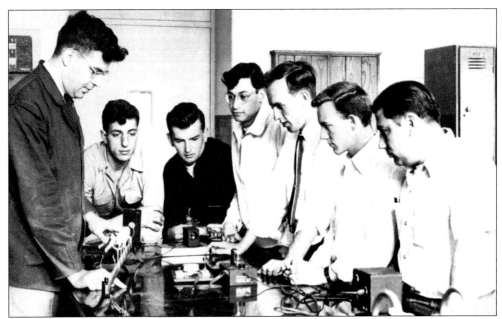

ARTS AND SCIENCES. When British author C. P. Snow famously bemoaned the separation between the two cultures, he certainly was not describing Brockport State Teachers College. Both had a major place in the curriculum. To serve the health and physical education program, Brockport established a strong science department. Even the future elementary teachers in general education took several semesters of science. When SUNY's teachers colleges were finally allowed to certify secondary school teachers, Brockport's first secondary certification program was in mathematics and science. In the wake of Sputnik, some educational critics unfairly attacked teachers colleges for excessive attention to pedagogy. On the contrary, Brockport State offered a well-rounded liberal arts education.

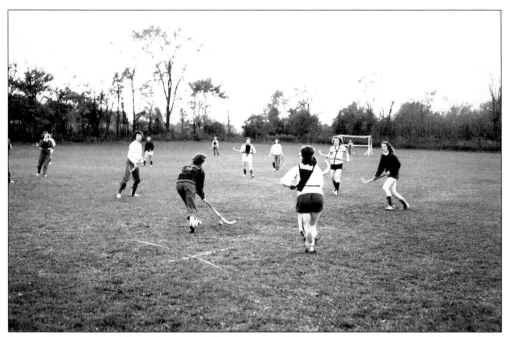

BODY CONTROL. Brockport's nationally renowned dance program emerged from a base in the physical education department's emphasis upon movement. Skills classes taught future physical education teachers how to teach a variety of activities and coach various sports. Brockport graduates have coached numerous teams across New York State and beyond.

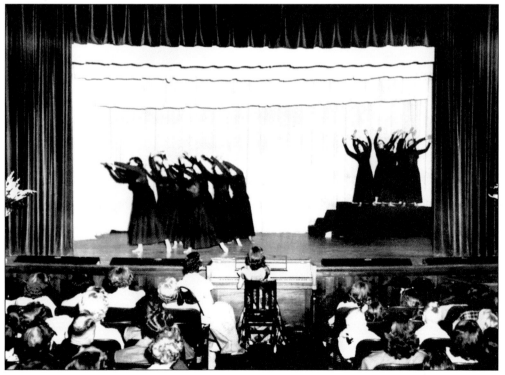

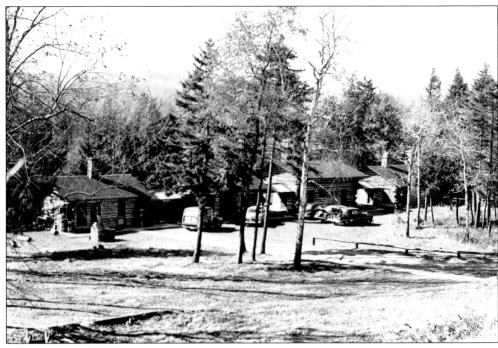

THE NATURAL LIFE. Training health and physical education teachers required a facility where students could experience outdoor life and camping. The college purchased an Adirondacks camp whose picturesque setting, and perhaps distance from the normal college rules, made it a popular getaway. Nevertheless, the distance was an obstacle, and in the early 1960s, the college sold Camp Totem and purchased land in nearby Fancher.

THE PIED PIPER. A student teacher leads her campus school kindergartners in a musical and patriotic exercise. John Dewey popularized the idea of a "laboratory school" with his work at the University of Chicago in the late 1890s. The idea spread, and for much of the 20th century, campus schools were an integral part of teacher training, providing a convenient and supportive place for observation and practice teaching.

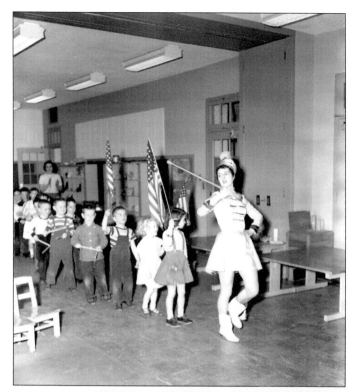

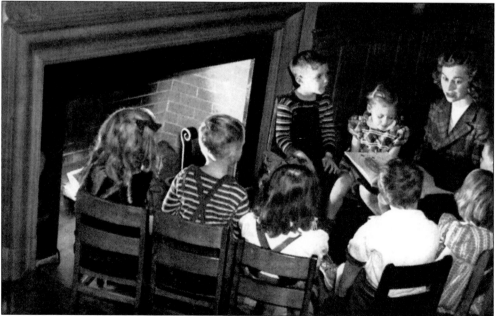

STORY TIME. The campus school in the new building included space for quiet moments as with this student teacher reading to entranced children. Campus schools demonstrated education at its best with talented teachers, small classes, and excellent facilities. The experimental progressive methods provided in these ideal conditions were more difficult to apply in less-privileged schools.

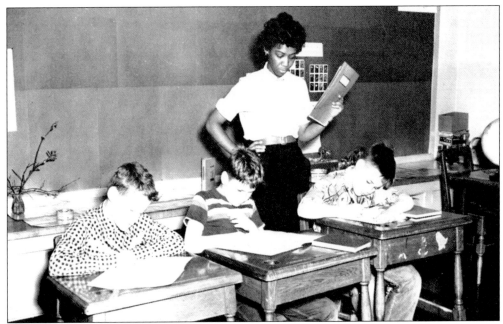

BACK TO THE BASICS. Even in the progressive campus school, the student teachers drilled pupils in the basics.

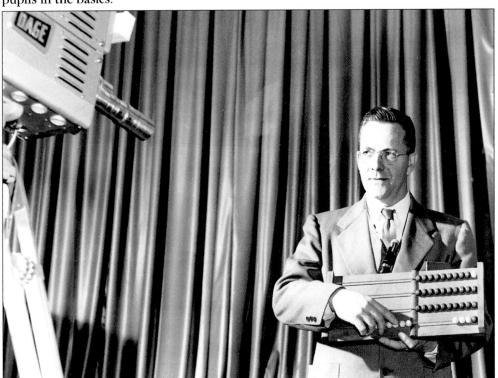

MR. WIZARD. Broadcasting lessons taught by master teachers offered one solution for schools struggling to find enough experienced teachers for the baby boomers. Brockport was a pioneer.

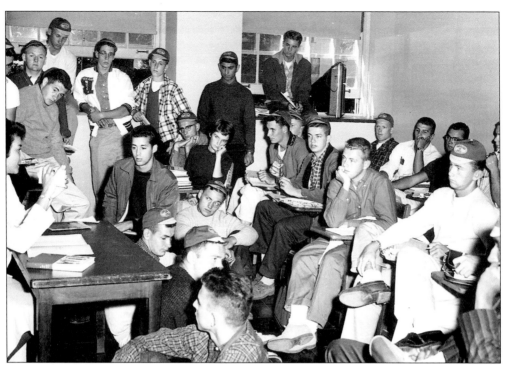

STANDING ROOM ONLY. Here young instructor Rosie LaSorte teaches health in a crowded classroom—not a subject to be taught in a mixed-sex setting in the 1950s. Enrollments began to rise again in the late 1950s, stretching the facilities beyond the comfort level.

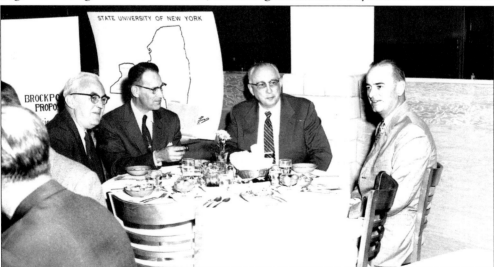

PLANNING FOR GROWTH. With baby boomers moving through the secondary schools, further growth was inevitable. In 1957, Pres. Donald Tower hosted a dinner to discuss plans for future expansion. The next year, Gov. Averill Harriman received a hearty welcome when he brought his unsuccessful 1958 reelection campaign to the campus. However, his defeat proved fortuitous for Brockport. His victorious opponent, Nelson Rockefeller, adopted SUNY as a pet project, and Brockport became one of the main beneficiaries of his enthusiasm.

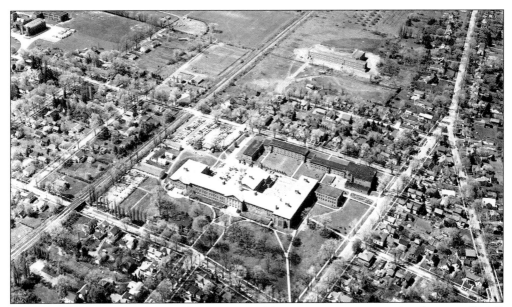

GROWING PAINS. Exploding enrollments inevitably meant expansion. Behind Hartwell Hall are the first permanent dormitories and student union. To the left are the "temporary" Quonset huts and veterans' housing. To the west, Thompson Hall, the first dormitory of the "lower quad" is nearing completion. The houses between the two parts of the campus are doomed, but in 1958, the village still surrounds the campus. New York State's rejection of Pres. Ernest Hartwell's plea in the 1930s to locate the new building in the open spaces south of the railroad tracks wrought painful consequences two decades later. The houses west of Kenyon Street blocked progress and were condemned. Some were razed while others were moved west along Holley Street. Millard and West College Streets disappeared, but the Village of Brockport successfully resisted closing Kenyon Street.

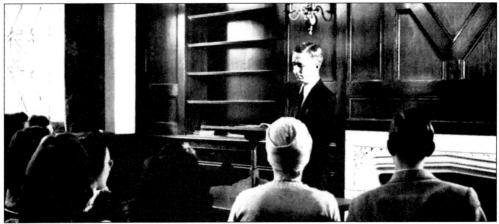

A COMFORTABLE COLLEGE COMMUNITY. The college offered a lively cultural life to students, faculty, and local residents. With stained-glass windows, dark wood, leaded windows, and a fireplace, the Shakespeare Room created a neo-Elizabethan atmosphere in which to appreciate the bard's works. After events such as this lecture, the Roxbury Inn at the other end of College Street provided an elegant place to eat and relax. The college's growth and social changes would put pressure on the cozy community atmosphere after 1965.

Four

CREATING A TRADITIONAL COLLEGE LIFE
THE POSTWAR GENERATION

The post–World War II generation arrived at an institution lacking a clear identity. Pres. Ernest Hartwell had abolished normal school traditions such as Color Day and the fraternities and sororities in the 1930s; then the war effectively suspended social life for the duration. When Prof. Wayne Dedman came to the campus in 1945, he found a college that lacked "roots and soul." The students who arrived at Brockport after World War II brought new energy and sensibilities with them and left an indelible mark on Brockport's student life.

The postwar generation endured severe overcrowding. When World War II ended, Hartwell Hall was the entire campus, one that accommodated the projected enrollment of 500 quite well. In addition to classrooms and offices, Hartwell Hall housed a gymnasium, bowling alleys, a swimming pool, Ma Green's cafeteria, a library, and a dark walnut auditorium. But these facilities could not comfortably provide for the soaring enrollments: more than 600 in 1946, 800 in 1947, and 1,000 in 1948. Lacking dormitories, the college initially had to rely on the village to house the unprecedented number of students. The arrival of war-surplus barracks and the construction of flimsy West Hall relieved the situation by offering modest accommodations.

Many veterans' needs differed from those of Brockport's traditional students. Six veterans registered for classes in September 1945; in the spring of 1946, a special accelerated group swelled their ranks to 85. Veteran enrollment peaked at about 300 in 1948, equaling the college's total enrollment in 1945. Two of the barracks had to be designated for married student housing, and children soon toddled around the campus. Despite psychological adjustments and physical inconveniences, many veterans now recall those years fondly.

Although most of their parents had not been to college, postwar students arrived with definite images of collegiate culture and demanded the full panoply of activities

and organizations they associated with "college life." Most prominent were the anthems and totems accompanying football. Newly arrived coach Robert Boozer organized a team in the fall of 1947 with equipment donated by a nearby army base. The soccer team, destined for national glory, was revived and cross-country, swimming, track, and golf teams were soon formed. The Women's Athletic Association provided an extensive intramural program and play days with other teachers colleges. But the teams lacked a mascot—students filled the void by the selection of the Golden Eagle.

Other traditions also began. Homecoming, first celebrated in 1947, became an annual rite of autumn. Christmas pageants, the Winter Carnival, and formal dances enhanced social life. The *Stylus*, founded in 1914 as a monthly, became a weekly campus publication. The *Saga* yearbook was in its heyday. Historians, including the authors of this book, are forever grateful to the hardworking student journalists who produced these enduring records. The late 1940s were also fertile years for student associations as new religious, musical, dramatic, and academic organizations flourished.

When the World War II veterans graduated, enrollments slumped, creating budgetary havoc for the administration but a welcome equilibrium between facilities and students. The opening of a new student union and women's dormitories in 1951 meant Brockport was no longer a one-building campus. The purchase of farmland south of the railroad tracks provided space for athletic facilities and physical education classes. On fall Saturdays, sizeable crowds of students and villagers gathered there for football and soccer games.

The postwar college remained closely connected to the village. All men and many women continued to live off-campus in carefully regulated private homes, making it easy for students to patronize village businesses such as the Landmark Hotel and the Strand movie theater. But after the college built new dormitories, destroying a residential area in the process, the campus became more self-contained and town-gown relations suffered.

For two decades after World War II, Brockport students developed a rich collegiate culture under careful faculty and administrative oversight. Those constraints would be challenged in the late 1960s, but many of the patterns and traditions of student life established by the post–World War II generation endure to the present.

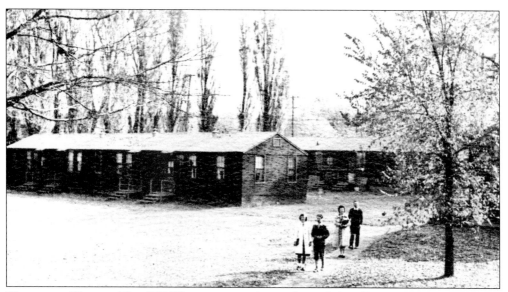

HOMES FOR HEROES. The GI Bill's unexpected popularity left colleges across the country scrambling to provide housing. When Brockport's enrollment doubled for the fall of 1946, the opening of classes was delayed for a week until 75 veterans and other students found private accommodations. Villagers responded to Pres. Donald Tower's plea to "remember Tarawa and Bastogne and Anzio." Housing was found for the veterans, enabling classes to begin. The next week, components of three apartments, which formerly housed GIs and POWs in Orangeburg, arrived and were reassembled in time for the spring 1947 semester.

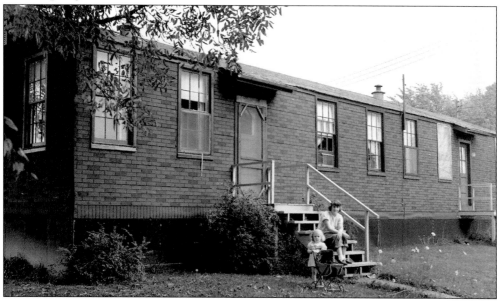

MARRIED WITH CHILDREN. These tranquil scenes must have been a welcome change from those veterans had recently experienced. The GI Bill bequeathed a new phenomenon to Brockport and many other colleges—married students with children. The GI Bill generation came to college with a sense of purpose and a maturity that often separated them from younger, traditional-aged college students.

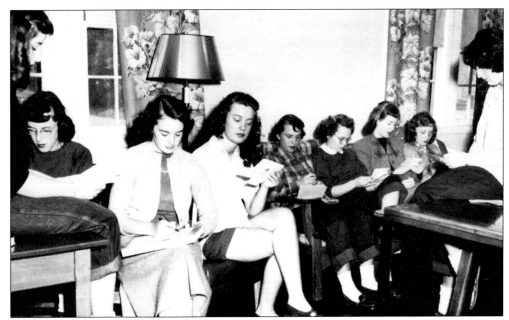

MAIL CALL. A temporary wooden dormitory was quickly erected to house 120 women by the railroad tracks, near today's Alumni Walk underpass. Hastily constructed and short-lived, West Hall legendarily was so poorly constructed that snow blew into the rooms, each housing eight students on bunk beds. House mother Helen Smith diligently enforced the 10:30 p.m. curfew, while students took advantage of the low windows to circumvent her vigilance. But most students lived in private homes, continuing the basket-boarding tradition, or commuted from home.

LIVING ON CAMPUS. In 1951, the first modern permanent dormitories opened for some lucky women. Constructed behind and parallel to Hartwell Hall, they offered students a new level of comfort. Neff Hall, between today's Morgan and Lathrop Halls, was demolished in the 1990s to provide an eastern extension of the mall to Hartwell Hall, removing a 40-year barrier to cross-campus movement.

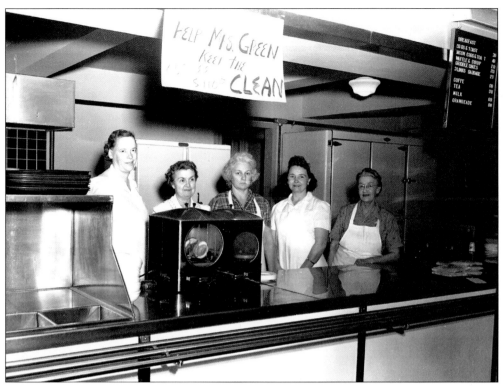

MA GREEN'S. In the 1940s, Ma Green's coffee shop, on the ground floor of Hartwell Hall, offered the only food on campus. Students could grab a bite to eat, smoke, play pinochle, and listen to a jukebox between classes. Completion of the student union (today's Lathrop Hall) in 1951 made full meal service available in a modern cafeteria.

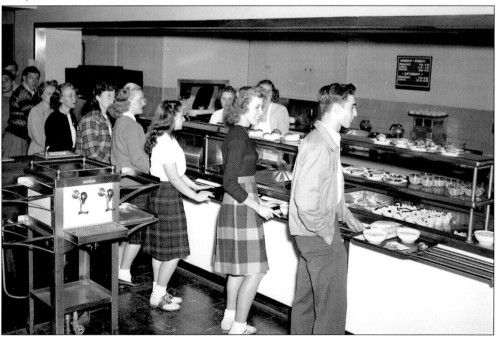

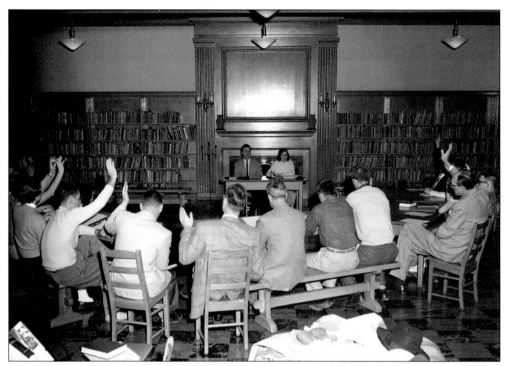

SHARED GOVERNANCE. Pres. Donald Tower's vision of a college community assumed a degree of shared governance. He established the Student-Faculty Association, shown here voting, to govern campus life. To some, this promoted student-faculty cooperation. To others, it resembled a high school student council that excessively limited student freedom. Below, Prof. Harold Rakov, longtime student favorite and namesake of today's Rakov Center, confers with two students.

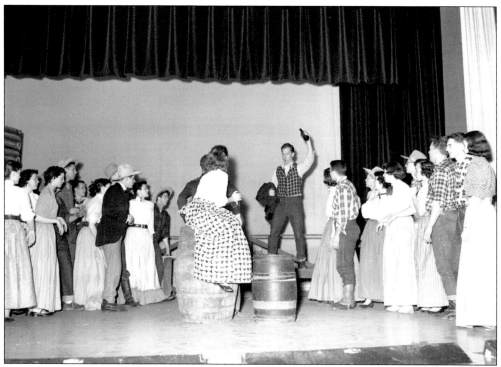

ONSTAGE. The Hartwell Hall stage was put to good use for student performances. Faculty joined students in numerous theatrical productions such as this 1952 version of *Goodbye, My Fancy.* A full orchestra poses in the Hartwell Hall auditorium with history professor Art Lee as the first violin.

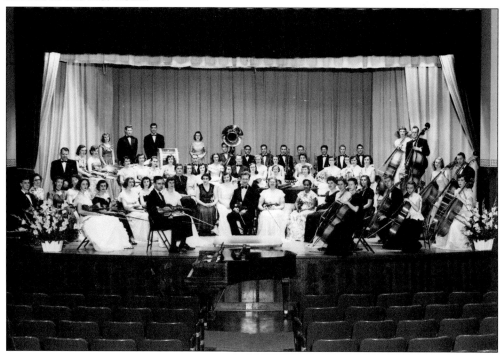

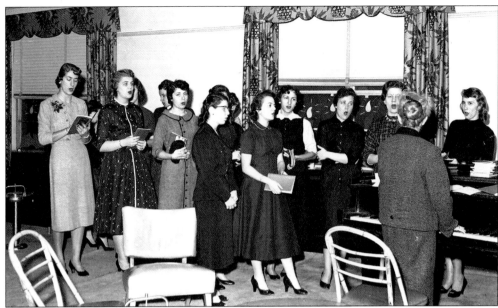

FILLED WITH MUSIC. Student vocal music was another venerable collegiate tradition that was established at Brockport in the postwar years. Here the women's chorus practices, and there was also an active men's glee club.

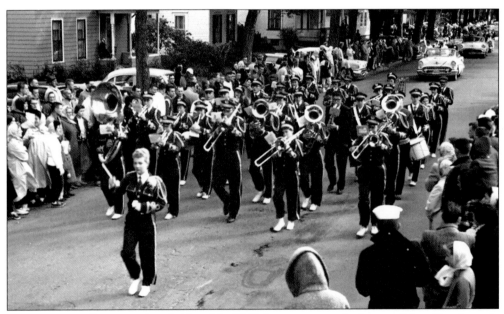

COMING HOME. Homecoming, initiated in 1948, became an enduring tradition. Brockport's collegiate life no longer terminated at graduation as alumni returned for class reunions, the football and soccer games, and a dance. The homecoming parade remains an autumnal ritual, starting on Main Street in the village and ending at the football field. The Brockport band, which marched at football and soccer games and for homecoming, no longer exists and is missed.

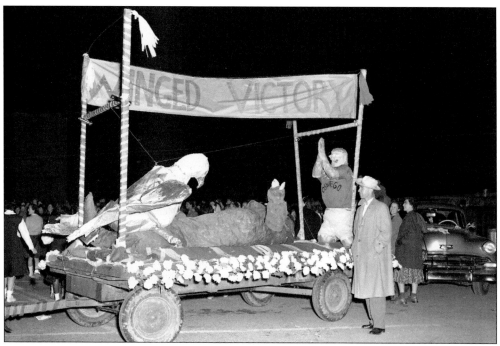

GOLDEN EAGLE VICTORY. Float competition was fierce, with elaborate ruses employed to keep the float designs secret to secure an advantage over rivals for the prizes. The veterans' float featuring a toilet became an annual tradition. "Winged Victory" probably did not win the design prize in the 1958 homecoming parade, but it certainly epitomized school spirit, portraying Oswego's mascot begging the Golden Eagle for mercy. The cheerleaders urged Ellsworth on to "inevitable" victory at the Friday night rally.

ELLSWORTH THE GOLDEN EAGLE. Soon a full panoply of teams competed for the college, including football, soccer, cross-country, swimming, track, and golf. And on the occasional sunny spring day, baseball games attracted supporters. But something was missing. The Fighting Irish of Notre Dame, the Nittany Lions of Penn State, and the Trojans of Southern California were nationally recognized mascots. The *Stylus* editors sought to fill the void and solicited nominations. Three furry alliterative nominees, the Badger, the Beaver, and the Golden Bear, shared the ballot with the feathered, non-alliterative Golden Eagle. On October 1, 1947, students solemnly deposited their votes in a ballot box in Hartwell Hall, overwhelmingly selecting the winged champion. But Brockport's mascot lacked a name and shape for nearly a decade after the Golden Eagle's election. Then the April 27, 1956, *Stylus* proclaimed that this void was to be filled; Brockport would "Meet Ellsworth the eagle on May 4." The campus eagerly awaited this anthropomorphic transformation. On Spring Day, a dapper, if slightly menacing, male fowl—designed by Bob Bloxsom (class of 1958), and named his creation for his football coach Robert Ellsworth Boozer—debuted.

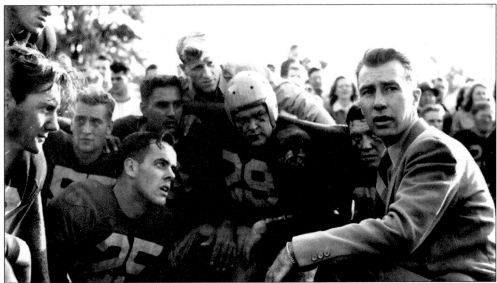

THE AUTUMN COLLEGE RITUAL. After World War II, Brockport students demanded the college life ingrained in American culture by movies, magazines, and sports. Football was central to that vision. Brockport's team began in 1947 in uniforms handed down from service teams. Half of the males on campus turned out for that first squad. Athletic director Ernest Tuttle prohibited recruiting and required that every player participate in every game. Here the players, including future coach Jerry D'Agostino (class of 1949), turn to coach Boozer for guidance at a tense moment. The college mascot and football field are both named in his honor.

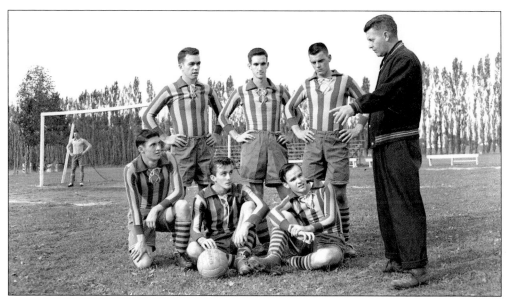

BOUND FOR GLORY. A. Huntly Parker relaunched the soccer team after the war and carried it to extraordinary success. A soft-spoken man who, according to his players, never showed anger, Parker coached numerous All-Americans. He was named to the U.S. Soccer Hall of Fame in 1993, one of the first 20 coaches to receive that honor.

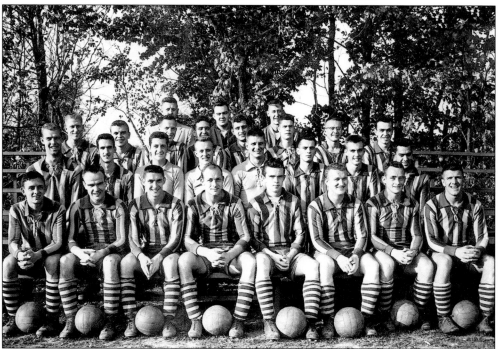

NATIONAL CHAMPIONS. The highlight of Parker's program came with the national championship of 1955, which was shared with Penn State University. A victory over West Point highlighted a second successive undefeated season that earned the distinction. Parker developed his team within Ernest Tuttle's demand for simon-pure amateurism; some of these players arrived in Brockport without prior competitive soccer experience.

WOMEN'S SPORTS. Although women's intercollegiate sports had fallen from favor nationally, intramural sports thrived at Brockport, and there was occasional competition with other colleges on "sports days."

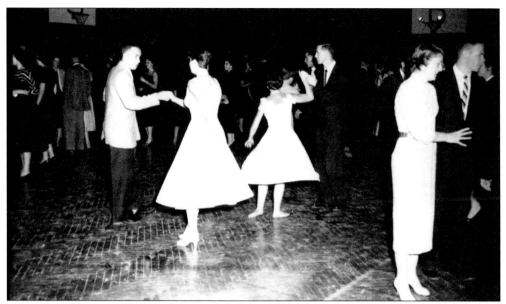

SWINGING. Formal dances were the social highlight of the year for many students. And they were formal. At the Christmas dance, couples approached a Hartwell Hall decorated with wreaths, walked up the steps, and passed under an arch of evergreens and holly to a receiving line where the freshman class president introduced each couple to Pres. Donald Tower and Helen Tower. In 1948, five couples announced their engagements at the Christmas dance, and the orchestra played their songs. Faculty often scheduled dinner parties to precede the dance. The Christmas Cotillion continued into the mid-1960s. But at other times, dancers swung more informally.

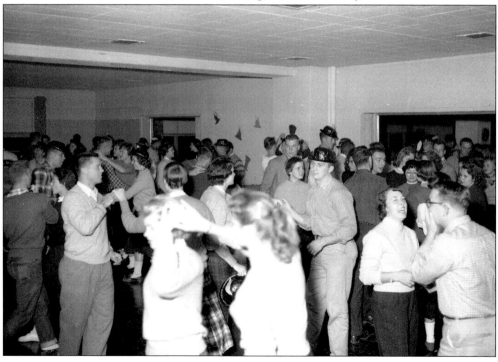

CELEBRATING THE HOLIDAY SEASON. Postwar Brockport included broadly Christian ceremonies such as Christmas vespers. For two decades after World War II, the college heartily celebrated the holidays. Students decorated trees in the Hartwell Hall lobby and the student union, caroled through village streets, and hosted a faculty children's party and a Christmas card writing night. Although today's sensibilities prohibit such all-college religious events, vespers then seemed a normal part of campus life. The women's and the men's glee clubs sang religious and secular seasonal music, the Christmas story was read, and Prof. Ian Henderson played the organ. After Christmas, the Winter Carnival celebrated Brockport's ambivalent relationship with snow.

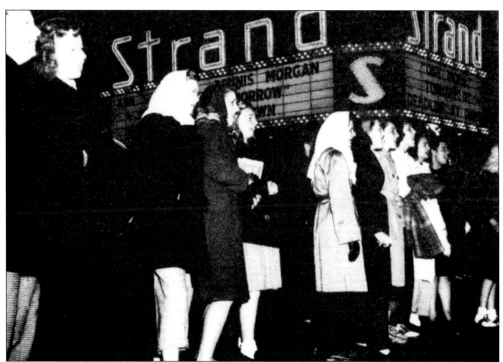

TOWN AND GOWN. The art deco Strand Theater was, and still is, a favorite destination for students seeking escape on the silver screen. Another favorite student hangout, the Landmark Hotel, burned in 1955.

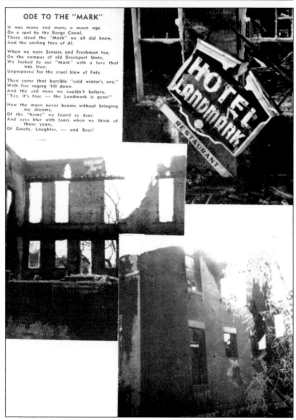

ODE TO THE "MARK"

It was many and many a moon ago
On a spot by the Barge Canal,
There stood the "Mark" we all did know,
And the smiling face of Al.

When we were Seniors and Freshmen too,
On the campus of old Brockport State,
We looked to our "Mark" with a love that
was true;
Unprepared for the cruel blow of Fate.

Then come that horrible "cold winter's eve,"
With fire raging 'till dawn.
And the sad news we couldn't believe,
"Yes, it's true — the Landmark is gone!"

Now the moon never beams without bringing
me dreams,
Of the "home" we found so dear.
And eyes blur with tears when we think of
those years,
Of Gaiety, Laughter, — and Beer!

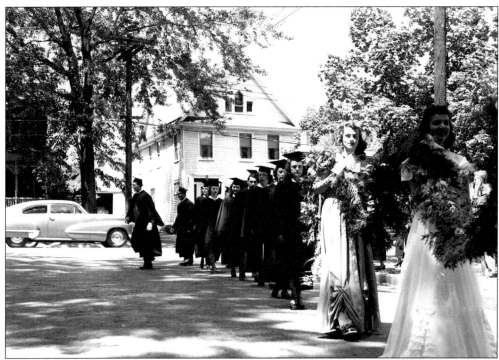

COMMENCEMENT. The ceremony's name marks the commencement of a new life but the end of college life. Underclass women carried the daisy chain, escorting the graduating seniors into the ceremony. In retrospect, the postwar generation could take satisfaction in having created a college culture at Brockport.

Five

THE LIBERAL
ARTS REVOLUTION
1965–1975

Gov. Nelson Rockefeller, newly elected, appointed the Heald Committee in December 1959 to study the state's current and future need for higher education. Its report, which was issued in November 1960, argued that the postwar demand for higher education would accelerate and that much of the projected increase would have to occur in the public sector, in fact, in SUNY. Consequently the committee recommended a dramatic expansion of the state university to provide for the hundreds of thousands of New Yorkers who would be seeking admission to public higher education over the next two decades.

Among the report's recommendations was a call to transform SUNY's teachers colleges into liberal arts institutions, a recommendation echoed in the university's revised master plan of 1960. At Brockport, plans to expand both the physical plant and the curriculum became the focus of the faculty, professional staff, and students, as new dormitories and classroom buildings were designed and built on the campus that was now developing along an east–west axis between the Erie Canal on the north and the railroad to the south. New departments in speech and philosophy were organized, and a liberal arts major became available to juniors and seniors (including transfers from the new community colleges) in 1963, and freshmen two years later. The campus also developed two off-campus sites, the Fancher campus (1964) located 10 miles to the west and an urban center in downtown Rochester 18 miles to the east.

Although blueprints for expansion and change had been drafted in the early 1960s, the expanded direction and ambition was largely the vision of Dr. Albert W. Brown, who became the college's third president in October 1965. A native of New York, he had been dean of the College of Arts and Sciences at Eastern Michigan University before being named that state's director of the Office of Equal Opportunity. He quickly put his stamp on both campus organization and plans for expansion. The existing "Ten-Year Academic Plan"

had estimated that the campus would serve 3,500 undergraduates by 1970, an increase of 1,000 in five years. Brown, who better understood the extent of the unmet demand for public higher education in the area, immediately changed the projections, and the campus's revised master plan projected 5,000 undergraduates by 1970, 7,500 by 1975. In 1968, the campus raised its enrollment projections again, to 10,500 undergraduates by the mid-1970s. By that date, the actual enrollment was almost 12,000.

Under Brown, Brockport instituted bold curricular innovations. Interestingly, almost alone among the SUNY colleges making this transition, Brockport eliminated its education majors, forcing students who sought certification to complete both an academic major and a certification program. In addition, a bevy of master-level graduate programs were launched for many of the new majors, and some departments even submitted ambitious plans for future doctoral programs.

By 1975, in one decade, Brockport State had been transformed from a small state teachers college into a large multipurpose college that was in the throes of constant change. New building projects were completed, distinguished new faculty had been hired, and academic programs created in fields as distinct as a major in the Peace Corps and a new interdisciplinary, time-shortened curriculum called the Alternate College. Brockport achieved national stature as a college that was making a uniquely successful transition from its teachers college past to a new, as yet uncharted, future. This was the heyday of the new Brockport.

PRESIDENT BROWN. The early years of the Brown administration were characterized by Dr. Albert W. Brown's willingness to engage the campus community in the issues attendant to the explosive growth of the late 1960s. To elicit community feedback to changing needs, he posted a large chart of the administrative organization outside his office in Hartwell Hall, with moveable parts, and then invited passing students, faculty, and professional staff to move the pieces around on the board. A new organization eventually emerged that had been endorsed by a consensus of interested groups across the college.

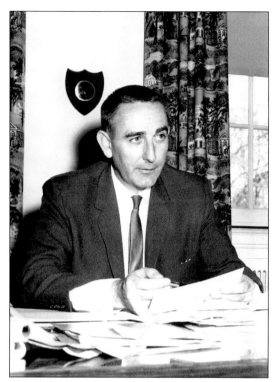

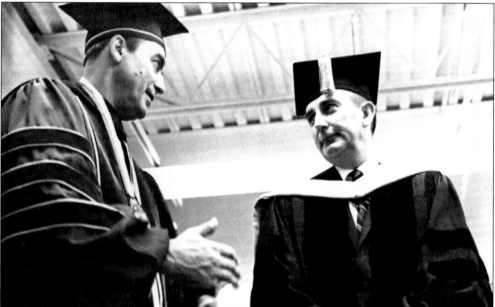

THE CHANCELLOR AND THE PRESIDENT. Samuel B. Gould (left) had been chancellor of the University of California at Santa Barbara and president of the Educational Broadcasting Corporation before his appointment by Gov. Nelson Rockefeller as the first chancellor of SUNY. Under Gould, the university expanded in size and mission. One of his first—and favorite—presidential appointments was Brown at Brockport, a campus that he thought needed new leadership. Gould formally installed Brown in office in the spring of 1966.

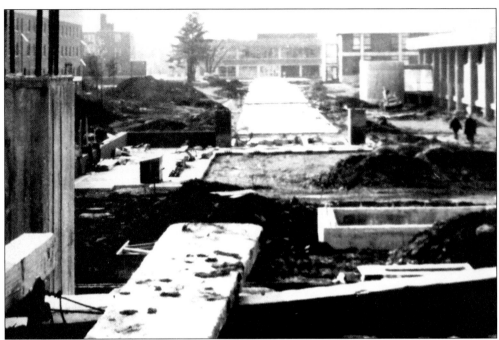

UNDER CONSTRUCTION. The late 1960s witnessed much of the construction that in the short run tore up the heart of the college, but that in the longer term created the modern campus. For years, the campus was ripped apart to make way for the construction to the west, with the classroom and office buildings and the middle quad residence halls all going up between 1965 and 1969. By 1969, with the completion of Edwards Hall, the campus north of the railroad was almost complete.

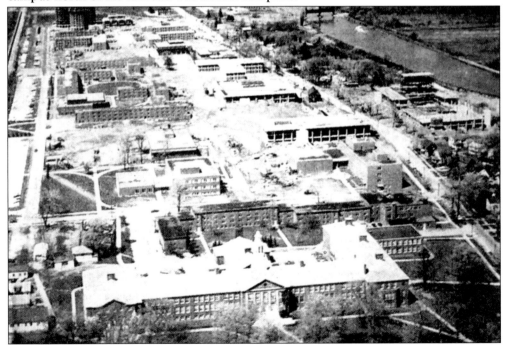

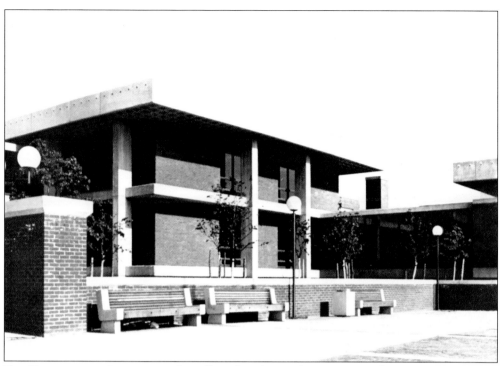

THE HEART OF THE CAMPUS. Smith Hall (1967), the student union (1968), and Edwards Hall (1969) surrounded the central plaza. These buildings shared with the adjacent Tower Fine Arts Building and Holmes Hall a common exterior style that used brick and glass window facades within concrete pillars, giving the campus a modern, but sterile, look.

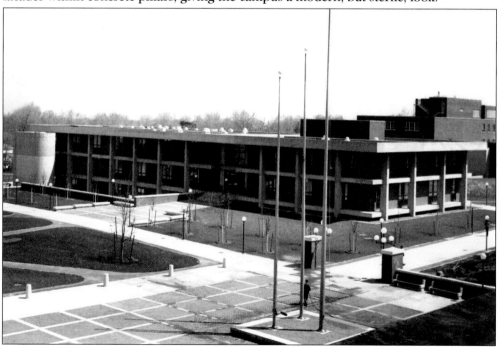

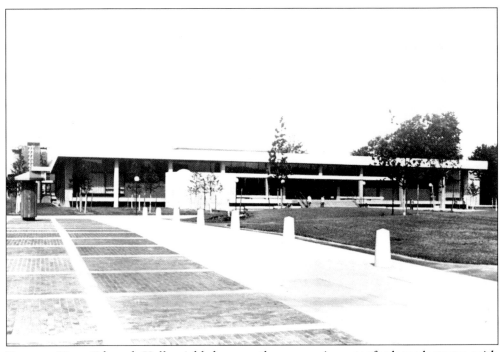

EDWARDS HALL. Edwards Hall quickly became the campus's center for large lectures, with a 450-seat auditorium and two 200-seat lecture halls, as well as two 100-seat classrooms. The building was designed as a state-of-the-art media learning center as well, with a central core area where a single staff member could service the media needs of the five large halls, three of which were equipped with multiple screens. The newly designated Educational Communication Center occupied the lowest floor of Edwards Hall, from which it created mediated instructional materials. Chancellor Samuel B. Gould wanted SUNY to become a national leader in the creation and use of new media technologies for education. The center produced slides, photographs, and television programs, to name but a few of the technologies that it offered the college's classroom teachers.

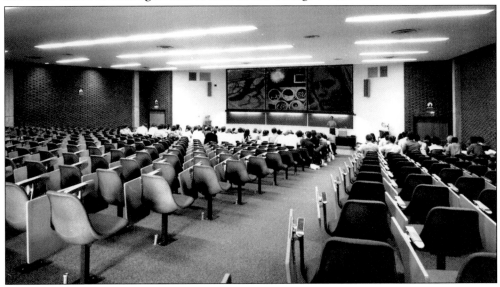

ON THE AIR. The new center built on the college's 1950s tradition of instructional television. A wide assortment of "shows" issued from Brockport Television (BTV), ranging from learned panels to art demonstrations to college math courses.

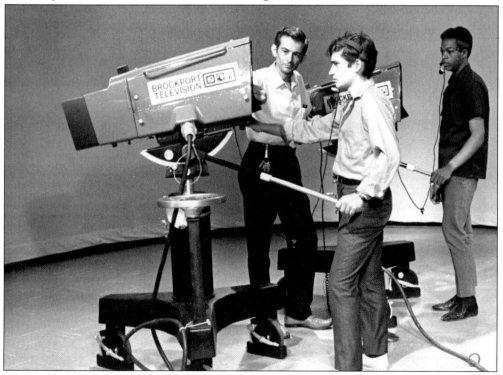

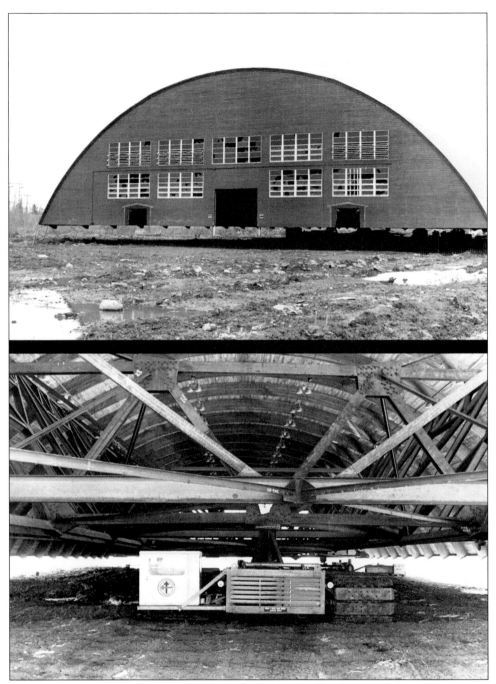

MOVING WEST. On the south side of the railroad tracks that bisected the campus stood the football field and a World War II surplus field house, one of many transferred to college campuses after the war. In March 1971, students and professors walking to their classes could see the field house slowly making its way to the west to make space for the new library, administration building, and gymnasium. It ultimately came to rest a mile to the west, where it continued to be used for the next two decades, before it was finally leveled after years of decay.

EARLY COMPUTER SCIENTISTS. The 1965–1967 catalog describes a liberal arts curriculum, with a single faculty, that by the next catalog had been transformed into four faculties (fine arts, humanities, natural and mathematical sciences, and social sciences) encompassing 19 departments. In 1969, the college offered students a computer science minor, a program that grew out of the strong base in the natural and mathematical sciences that the health and physical education program had required in corequisite courses. Three years later, growing enrollments led to an academic major, a growing program led by Prof. Norman Plyter.

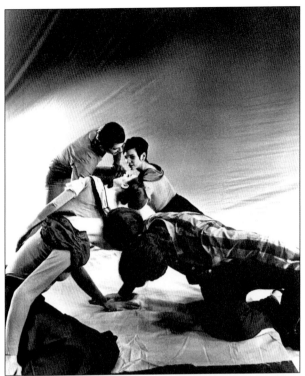

RESIDENT DANCE COMPANY. Rose Strasser, who had been a member of the Women's Health and Physical Education Division became the first chair of the new dance department. Within a few years, she had hired a half dozen young dancers, who in turn attracted a large number of talented and committed students. In 1969, several of these younger members of the department formed a resident dance company, one of the few based on a college campus. For the next five years, the Brockport Resident Dance Company, under the direction of James Payton, toured the state, building a reputation for artistic excellence.

THE MUSIC MAN. In addition to dance, the fine arts included the theater, music, and art departments, the last of which featured an extraordinary group of young artists. Each summer, the theater department produced a musical, as part of the college's long-standing Summer Arts Festival. Here the department chair, Adam Lazarre, plays the Music Man.

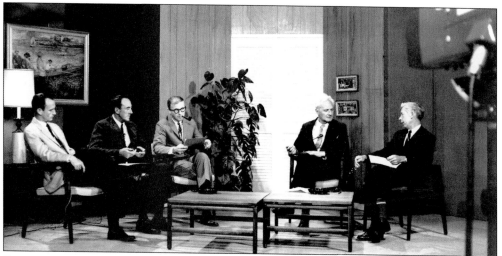

WRITER'S FORUM. In 1967, the English department launched the Writer's Forum, featuring distinguished guest writers. In its first four years, it brought more than 60 authors of fiction, non-fiction, and poetry to the Brockport campus for public readings and interviews. Pictured here are four members of that department interviewing noted British poet and essayist Stephen Spender. With ongoing support from both the college and foundations, the program has enriched campus cultural life for four decades.

INTERNATIONAL PHILOSOPHICAL YEAR. In that same year, Howard Kiefer, associate dean of the humanities, applied for a sabbatical leave to study contemporary philosophers, to which Pres. Albert W. Brown responded by asking him to bring those philosophers to the campus. Thus was born the 1967–1968 International Philosophy Year, a year-long series of lectures and panels by the leading philosophers of the time that proved so successful it was offered continuing support by Chancellor Samuel B. Gould. The Center for Philosophic Exchange continues to the present, bringing outstanding philosophers to the larger campus community.

CROSSING BORDERS. The unique Peace Corps program recruited its first class in 1968. The idea for a four-year degree program grew out of a conversation between Jack Vaughn, the director of the Peace Corps, and Pres. Albert W. Brown. Under the direction of Prof. John C. Crandall (pictured here), the program offered science and math majors an opportunity to acquire cross-cultural training and develop Spanish language skills as preparation for a Peace Corps assignment in Latin America.

HEALING ARTS. In addition to hiring hundreds of new faculty members to teach in the liberal arts programs between 1968 and 1971, the college created new professional programs, laying the foundation for the "comprehensive college" that would emerge in the next decade. The first of these was nursing, which accepted its first class in the fall of 1969.

FOUR INTO THREE WILL GO. The Alternate College was another example of the innovations of the era. Under the leadership of Dean Armand Burke, SUNY Brockport was one of six colleges awarded a major Carnegie grant to develop a three-year baccalaureate curriculum, which was achieved largely by reconfiguring general education requirements into an interdisciplinary core program and by reducing the number of credits required for a baccalaureate degree from 120 to 96. In the fall of 1973, the program admitted its first freshman class of 300, and, with its own space and a shared (mostly younger) faculty, it created a smaller learning community within the larger college. One of the hallmarks of the Alternate College was small seminars, often led by young faculty.

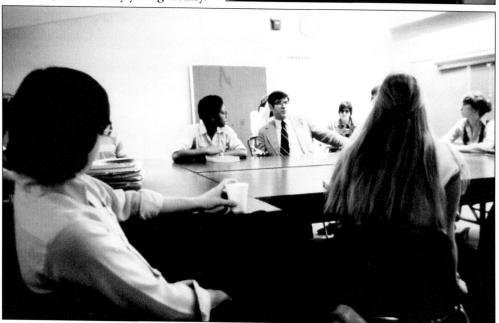

A College Transformed. The Brockport campus of this decade was incredibly lively, a place in constant turmoil with new buildings, new—and more—students, and new—and more—members of the teaching faculty and professional staff. Many students were driven by the opportunity to earn a degree, especially those who were the first in their families to attend college. For many faculty and staff, however, their ambition was often expressed in what proved to be the vain hope of the college becoming the fifth university center in the SUNY system. Whatever the ambition, the realities of the time forged a distinctive period in the college's history, an era of exciting—and messy—growth.

Six

TRANSFORMING STUDENT LIFE
THE 1960s

"The sixties," a common misnomer applied to student culture of the Vietnam War era, is just a shorthand evocation of a cluster of lifestyle changes involving sexual behaviors, student protests against America's traditional race relations and the war in Vietnam, and increased use of illegal hallucinatory drugs. In other words, "sex, drugs, and rock and roll." If the stereotype has any currency at all, it was for a minority of youth who entered a transitory late-teen culture that opposed traditional standards of dress and behavior. Even so, it did not begin until the late 1960s, after the birth control pill had reduced fears of pregnancy from premarital sex and after the war in Vietnam had escalated until a half-million U.S. servicemen were there. The ugly fighting by then appeared nightly on the network news. In the late 1950s and early 1960s, some college students had become sensitized to the need for political and social activism through the civil rights movement, and by the late 1960s, campuses formed the seedbed for large-scale opposition to the growing war. Brockport, like many other campuses of the period, experienced protests and disruptions.

The election of Warren Foster, an African American, in 1955 as president of the Student-Faculty Association and the reign of Bert Mann, another African American student, as king of the Winter Carnival in 1962 demonstrated a campus tradition of racial openness. The *Stylus* articles, in fact, reported these events without any mention of race. However, as the civil rights movement generated significant publicity among college populations throughout the country, consciousness of race changed. The *Stylus* featured sympathetic stories about students participating in a Montgomery, Alabama, protest in 1965 and on-campus support for local programs, such as Rochester's Operation Pride, which was designed to assist disadvantaged youth. By the late 1960s, the increased number of African American students led to demands for separation and for new programs, demands that the administration largely met.

As race created divisions among students, so too did the growing war in Vietnam. Through 1967, Brockport student attitudes toward the war were generally supportive of the Johnson administration, but that changed by 1969, after the Tet offensive of early 1968, the assassinations of Martin Luther King Jr. and Robert Kennedy, the Chicago riots, and the presidential campaign. Many supported the moratorium of October 1969 and the post–Kent State protests of May 1970, during which several campus buildings were seized.

While an increasingly vocal part of the student body had been politicized by the early 1970s, most students remained largely nonpolitical, with their time devoted to work and study. Despite shifting sexual mores and increased drug use, alcohol remained an extremely popular intoxicant. In 1969, the college turned the basement of the recently opened student union into a bar, the Rathskeller, where students could drink before walking (or stumbling) back to their residence halls. By the early 1970s, the 1950s genteel, formally attired Spring Day had been replaced by Spring-In, a Brockport Student Government–sponsored event featuring loud music and beer trucks that drove onto campus and opened their spigots for one and all. Classes were cancelled on the spot, as the electric guitars wailed far into the night, inviting all to a raucous party.

Yet SUNY Brockport was still a college, a place of learning where student culture met the higher culture of the arts, the sciences, the humanities, and the professions. Art exhibitions, dance recitals, intercollegiate athletics, movies, speeches by distinguished guests, and faculty panels focusing on significant issues of the day were commonplace in the weekly campus calendar. Newly hired faculty sought to re-create in their students the intellectual, artistic, and professional enthusiasm that had driven their own educations, and in the process, they imbued Brockport student culture with a yeasty ferment of ideas.

Education, in the most fundamental sense, lay at the heart of the Brockport student experience; it is what many students most treasure about their undergraduate experience and what they remember as its greatest legacy. Ideas still mattered.

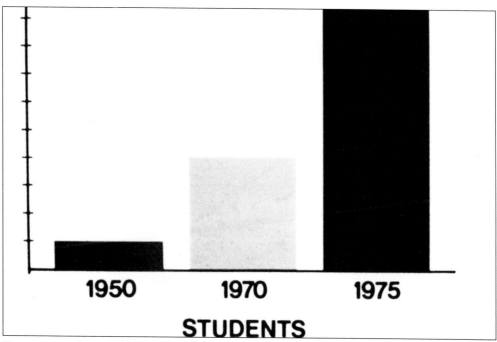

1950 1970 1975

STUDENTS

ENROLLMENTS RISING. Changes in the broader culture, especially the alliance of the growing civil rights and antiwar movements within the youth culture, influenced the character of student life on college campuses across the nation during this decade. At Brockport, these melded with the aftereffects of booming enrollments, which included overcrowded housing, endless lines, and overenrolled classes to create a particular campus culture.

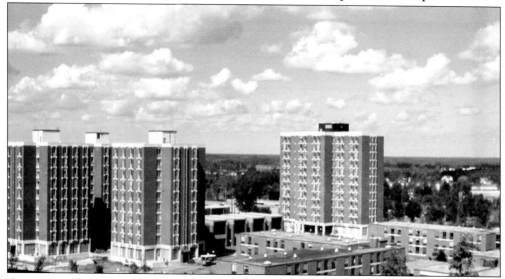

GOING UP. The three-story residence halls of the "middle quad" built in the mid-1960s (foreground) were the first on campus to offer suites, with a common lounge and bathroom attached to two bedrooms. The next residence halls (Perry, Bramley, and Briggs, on the left) went up, literally up, soon after. The last and tallest of the "high-rise" halls, Mortimer, was occupied in 1970. Even with these additional beds, by the early 1970s, many students were being tripled in rooms designed for two.

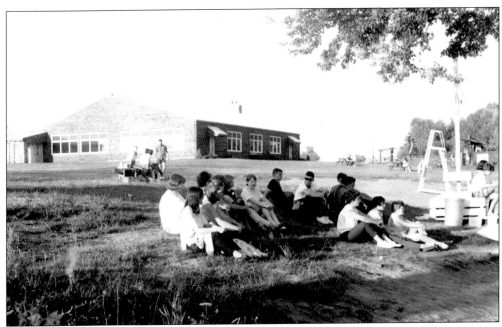

Go West. In 1963, the college acquired the Fancher Campus, 12 west miles of Brockport. Fancher, which was ready for occupancy in the fall of 1965, included a conference center, an outdoor swimming pool, a lodge, and a 10-acre lake set among 500 acres of woodlands, open fields, and swamp. The site was used for biological study, student recreation, a camping program, and innumerable faculty gatherings. In the early 1970s, for example, it hosted the first meetings of a national group of historians who later formed the Social Science History Association.

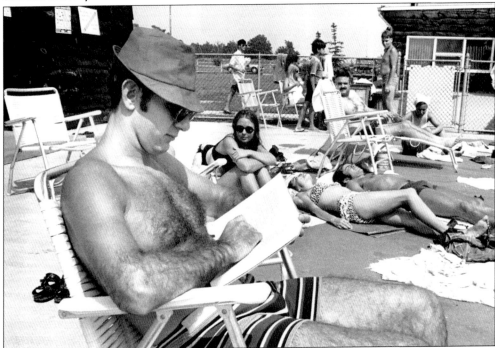

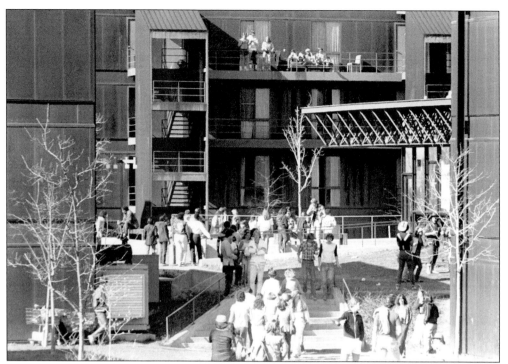

STAGE **XVI.** Opened in the fall of 1973 at the western edge of the campus, this innovative residential complex of 19 buildings used Cor-Ten steel exteriors designed to oxidize to a "rich, warm brown." They provided apartments, with plentiful common spaces, for 1,000 residents. Its completion marked the end of tripling on campus and fewer opportunities for area landlords, who had profited enormously at students' expense. Although the design was named the "best college living quarters in the country" at the fourth annual College and University Architectural competition, a flood in May 1973 ruined 140 of the apartments. This was just the beginning of the many problems that plagued this ill-fated complex.

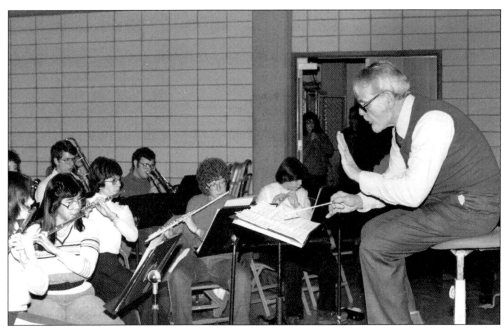

MAKING MUSIC. The fine arts enlivened the campus, and the new Tower Fine Arts Building had practice rooms available for groups large and small. Here Prof. Ira Schwartz rehearses the student members of the Brockport Golden Eagle Band.

DANCE, DANCE, DANCE. Dance did not always stay in the studios, and weather permitting, passers-by often saw dancers practicing on Hartwell lawn.

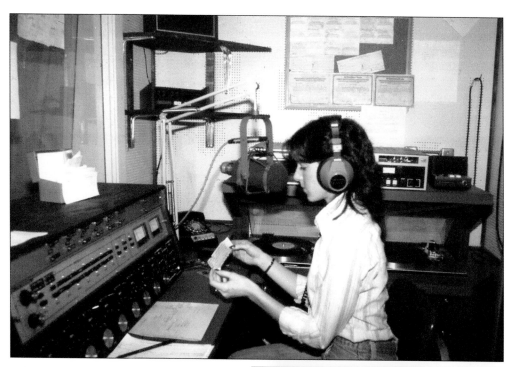

PUBLICATIONS. Students controlled campus media, including the campus radio station, WBSU, and the campus weekly newspaper, the *Stylus*. They also produced the yearbook, the *Saga*, as well as *Vista*, the campus literary magazine that was renamed *Our Original Sins* in 1968 under the editorship of James Howard Kunstler.

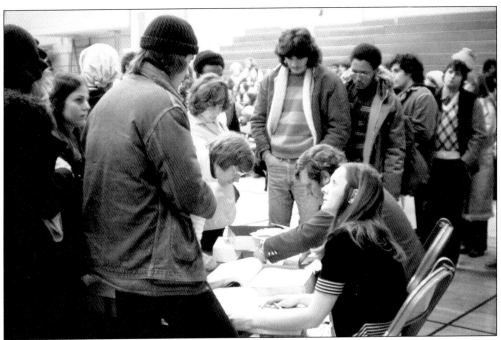

TRYING TO GET A CLASS. For many new students, the first introduction to campus life was final registration, a biannual mob scene held in the gymnasium where students jockeyed with one another for seats in required classes. Sometimes, when they really got desperate, they would take any available seat, no matter the class, just to get a schedule so they could plead with faculty members to admit them into their classes at the beginning of the semester.

FULL CLASSES. Once registered, students often then faced large lectures, with 200 students in a class. The largest lecture hall on the campus, the Blue Room in Edwards Hall, sat almost 500, and it was often filled. "Individualized" instruction was one variant of the western civilization course, offering students mediated materials designed to supplement the lectures. They viewed the lessons in the basement of Edwards on Norelco machines that were soon obsolete.

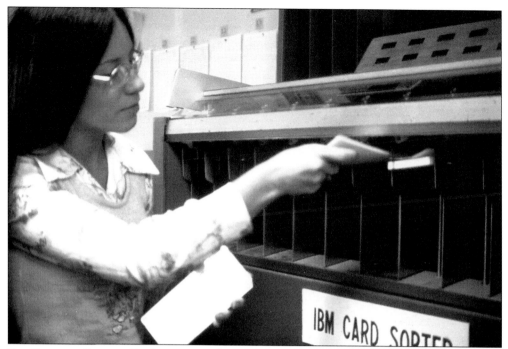

BIG BLUE ON CAMPUS. Each IBM punch card carried the warning "Do Not Fold, Spindle, or Mutilate." Once damaged, it could not be read by the machine, and since these were the ticket to class seats, students treated them with respect. But they also symbolized the depersonalization of overcrowded colleges and universities as the baby boomer generation overwhelmed campuses.

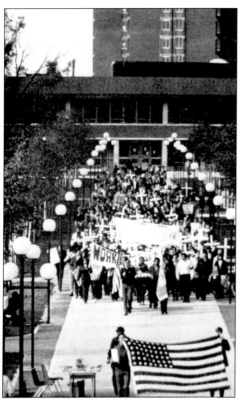

THE VIETNAM WAR AT HOME. Student protest came to Brockport as it did to many other campuses across the land. Although the violence experienced elsewhere—at Columbia, the University of Wisconsin, even neighboring SUNY Buffalo—never spread to the Brockport campus, the antiwar protests nevertheless were often large, as evidenced in this photograph of a march in the fall of 1969.

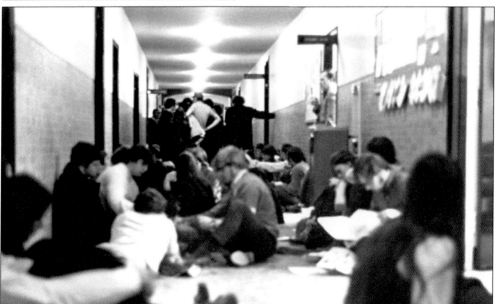

SITTING-IN. Some protests were more important to students than to others. This photograph documents a sit-in outside the president's office of students who objected to the campus dining hall food. In the aftermath of the Kent State shooting in May 1970, student protestors again seized Hartwell Hall, and only the deft handling by the administration kept at bay a contingent of local law enforcement officers ready to storm the campus.

THE RATHSKELLER. In 1969, the college opened the Rathskeller in the basement of the new student union in place of a planned bowling alley. It became the on-campus watering hole for students who had reached the then-legal drinking age of 18.

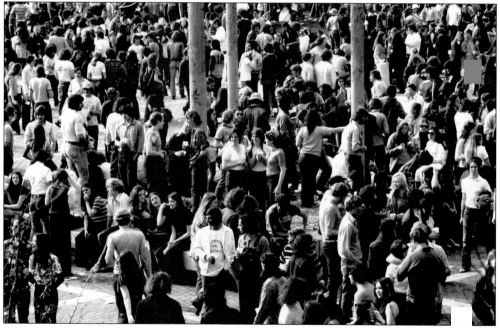

SPRING-IN. Spring-In became a legendary, but short-lived, tradition, especially for the local high school students who flooded the campus when they heard the music crank up on some randomly chosen sunny April afternoon, heralding the arrival of beer trucks in the campus's central quad. This annual bacchanalia captured the spirit of student culture in the 1960s: sunshine, dancing, music, booze, and classes cancelled by the order of Brockport Student Government. It just did not get any better than that.

WOMEN'S INTERCOLLEGIATE ATHLETICS. In the late 1960s, well before the enactment of Title IX that required gender equity in athletics, several Brockport women's teams achieved varsity status, beginning with basketball and volleyball in 1966 and then field hockey and tennis in 1968. It was several decades before the number of women's teams equaled those fielded for men.

AIMING HIGH. While the football team continued to struggle, achieving winning records only in 1971 and 1973, men's basketball earned national rankings, finishing fourth in the NCAA Division III playoffs in both 1973 and 1975, filling the gymnasium for every home game. This story ended badly in 1975–1976, when the team had to forfeit a number of games due to ineligible players. A year later, with the appointment of a new athletic director, basketball coach Mauro Pannagio was reassigned to teaching duties, ending his coaching tenure at the college.

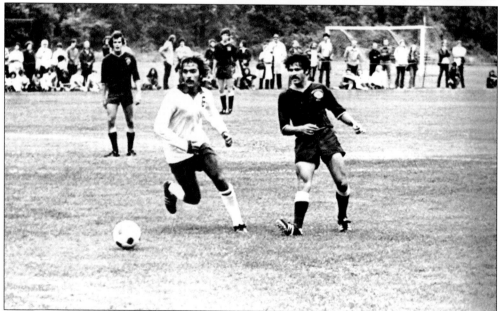

A CHAMPIONSHIP SEASON. Since athletic teams were funded by Brockport Student Government, the intercollegiate athletic program suffered constant disruptions through this period. In November 1973, for example, a year before its national championship season, the men's soccer team failed to compete in the NCAA regional postseason tournament, despite their No. 1 ranking in New York State, because no agency on or off the campus would or could fund the postseason.

CHANGING FACES. For most students, the turbulent 1960s were spent working with professors and other students to explore new knowledge through the development and refinement of skills. The student body not only grew but became more geographically diverse, with many students coming all the way from Long Island, especially Nassau County. The college actively recruited more transfers, as well as more African Americans, who changed the campus by establishing student organizations such as the Black Student Liberation Front and pressuring the administration to create an African American studies department.

Seven

THE CRISIS
1975–1985

In the fall of 1975, the college's enrollment reached 11,696, as more than 3,400 new full-time undergraduates, including 2,000 freshmen, joined the student body. Yet beneath these glossy numbers lay some troubling facts. When the baby boom bubble subsided in the late 1970s, the number of New York State high school graduates fell, especially in western New York. The transfer population, critically important to the college's growth in the late 1960s, peaked in 1970, thereafter declining as private colleges and universities started to recruit transfers. Bundy aid, a state-funding formula that paid New York's private sector for each degree, no matter the graduate's home state or the number of years at the college, made transfers especially attractive. Consequently, by 1980, Brockport's enrollment decline had turned into a free fall, with almost 25 percent fewer students than had been enrolled five years earlier. In its attempt to maintain enrollments, the college dipped deeper into its applicant pool, resulting in a precipitous decline in average SAT scores over the last half of the decade.

Personnel changes, at both the state and local level, added to the college's troubles. Nelson Rockefeller, who had driven the ambitiously expansive plans for SUNY, left Albany for the vice presidency in 1973 and was replaced by Hugh Carey, who never made SUNY a priority for his administration. Locally the administrative team that had served the college so well during the previous decade retired and was never effectively replaced. And when Ernest L. Boyer succeeded Samuel B. Gould, SUNY's first chancellor and main architect, he reorganized the administration, quieting some voices in Albany that had supported the college's expansion.

New York State's fiscal problems during the decade grew out of New York City's threatened bankruptcy, a situation that required a significant bailout by the state in 1975. SUNY was one of many state agencies to suffer. In 1975–1976, the state university instituted a system-wide retrenchment that led to the release of 18 Brockport professors. Even though 16 were eventually reinstated before the beginning of the next academic year, distrust between the faculty and the administration grew. Even after the immediate fiscal crisis in New York City was relieved, state finances suffered from the stagflation that slowed growth throughout the nation. Consequently, public funding for the

state university remained flat for a decade, and a second retrenchment was ordered in 1982.

At Brockport, enrollment shortfalls meant that fiscal problems would have a disproportionate impact, and retrenchment became John Van de Wetering's first order of business in his inaugural year, 1981–1982. By the summer of 1982, his administration crafted plans to eliminate a dozen administrative personnel and over 50 full-time teaching faculty positions, including the geography and music departments. Despite a year's grace for those affected, the losses devastated the professional staff and teaching faculty.

Students, however, were more directly affected by the change in state law that raised the drinking age (in stages) from 18 to 21. The Rathskeller closed, and by 1981, Spring-In had become the subject of local lore. Despite all these problems, the normal routines of student life continued, with classes, athletic contests, art openings, dance recitals, and special events.

In August 1979, the International Special Olympics offered a brief respite from the college's mounting problems. It remains a symbol of the twin themes of engagement and community outreach so characteristic of the college. In the face of growing questions about the quality of a Brockport education and the realities of declining resources and fewer students, the college community mobilized hundreds of volunteers to host the games that brought thousands, including a stellar national and international audience, to the campus. The games were a great success and left a new stadium and two massive sculptures as visual reminders of what the college, at its best, could accomplish.

By 1985, the college's enrollment had stabilized, even with higher published admission standards, but at a much lower level than even 1980. The student "head count" was a third smaller than it had been in 1975. A smaller student body necessitated a smaller professional and teaching staff as well. By 1985, the teaching faculty was also one-third smaller than a decade earlier. To some extent, the college had adapted to its new environment by concentrating on recruiting more part-time undergraduates and graduates from the greater Rochester region. Beyond that, however, it struggled to define the unique value of a Brockport education.

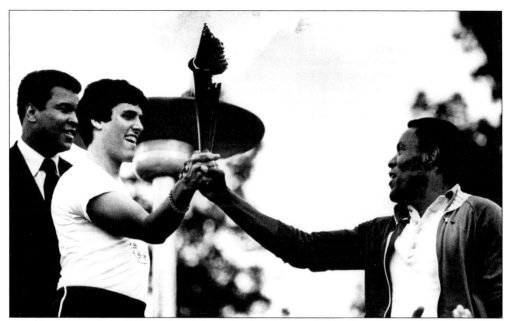

LIGHTING THE TORCH. The International Special Olympics drew over 3,000 participants and thousands of other guests, including a passel of Kennedys, Muhammad Ali, Olympic decathlon champion Rafer Johnson, who served as coach for the U.S. team, and scores of other famous athletes, both amateur and professional. On August 8, 1979, the torch was lit, beginning the five-day competition.

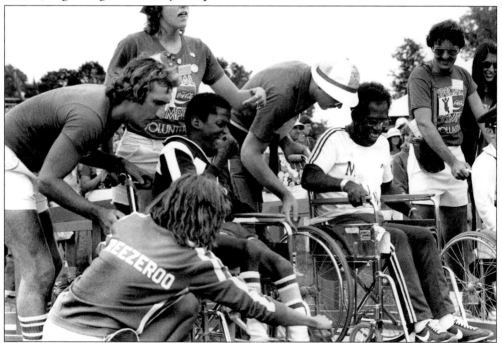

STUDENT VOLUNTEERS. Volunteers turned out as needed, making certain that each Special Olympian got to the starting line and then received a warm hug at the finish. Students, faculty, professional staff, and townspeople all gave unstintingly to make the games a success.

PROMETHEUS AND HAPPINESS FOR ALL THE CHILDREN OF THE WORLD. When the games ended and the crowds left, the campus returned to its normal rhythms, unable to translate the legacy of extraordinary accomplishment into attraction to potential students. Yet the two monumental sculptures, gifts from the Soviet people and the Georgian artist Zurab Tsereteli, reminded the community of those magical days of August 1979. *Prometheus* stands in front of the Allen Building, a symbol of the gifts, including fire and knowledge, given to mortals by this Greek god, while the larger piece, nicknamed "the Lollipop Men," became the centerpiece for Special Olympic Park.

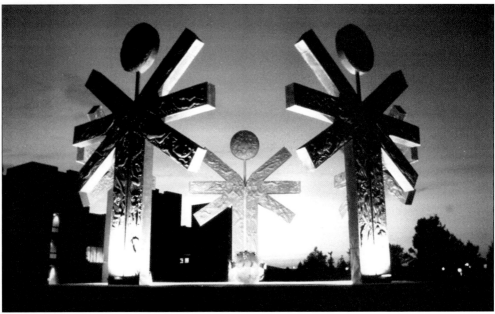

A New General Education Program. In 1979, the Faculty Senate concluded two years of study and passed a new general education program that attempted to bring greater intellectual coherence to the existing distribution requirements. It also added a new contemporary issues course, which reflected the late-1970s belief that modern education failed to address the moral issues raised by modern culture. The program, copying the Alternate College model, also established a one-credit advisement seminar for every freshman to explore the possibilities of education. For that course, the faculty created the *Dimensions of Liberal Education* handbook, a collection of 21 short essays covering a wide range of topics that became the course text.

DIMENSIONS OF LIBERAL EDUCATION AT BROCKPORT

State University of New York
COLLEGE AT BROCKPORT

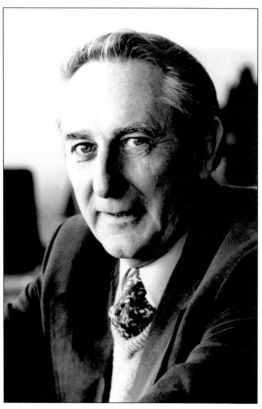

Dr. Brown Retires. In the fall of 1980, Dr. Albert W. Brown announced his retirement, effective the following summer. His 16-year presidency had shaped the modern college into a large, multipurpose institution that rested upon the traditional foundation of undergraduate teacher training, especially in physical education and health, allied with a wide range of traditional liberal arts programs and departments. The building process had been messy, the result often chaotic, and in the end, the last five years had been characterized by ineffective administration and declining enrollments.

"THE TROUBLE AT BROCKPORT." In October 1980, *Upstate* magazine published a long piece, "The Trouble at Brockport," using a cracked school beer mug as a symbol for what had gone wrong during the previous half decade. While adding to the college's woes in the region, it gave a number of faculty and staff, led by Prof. Lynn Parsons, an opportunity to publicly identify issues. The larger problem derived from the college budget, relying on enrollments, which meant the college was facing a crisis. SUNY Brockport, according to the *1981–1982 Middle States Review*, was a college in serious trouble.

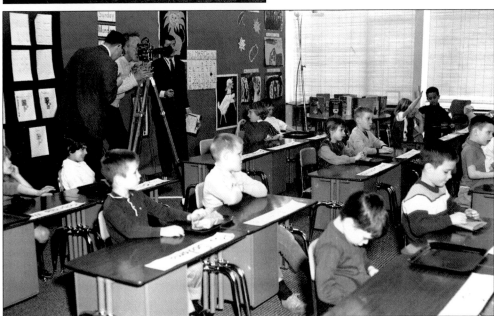

THE FIRST CUT: THE CAMPUS SCHOOL. In 1980, the SUNY Board of Trustees offered local campuses the option of ending their demonstration schools, as long as those programs were not essential to education in the immediate region. During the spring of 1981, a budget crisis loomed over Brockport's campus school, and just after assuming his presidential duties, John Van de Wetering closed the school after federal funding for a program that transported inner-city children from Rochester was terminated.

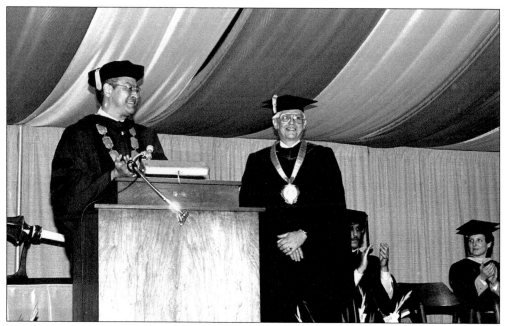

DR. VAN DE WETERING WITH CHANCELLOR CLIFFORD WHARTON. In late spring of 1981, the presidential search committee selected John Van de Wetering (right), an American historian who was president at Eastern Montana University, as the college's fourth president. Even before his investiture in office the following spring, he understood that his first task would be to reduce the number of college personnel.

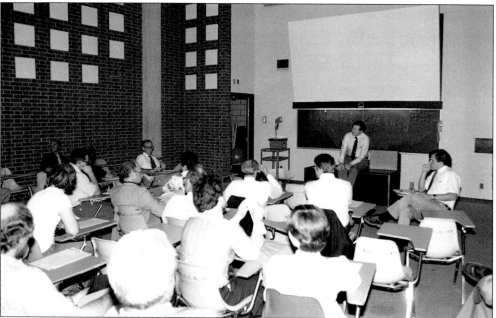

FACULTY COLLOQUIUM DURING INAUGURATION. This faculty colloquium, offered by physics professor Edward Gucker, was one of a series of presentations featured during the inaugural week that explored the relationship between "Science and Human Values." The festivities concluded with a semiformal dance.

State University of New York
COLLEGE AT BROCKPORT
Brockport, New York 14420

Office of the President 716-395-2361

June 22, 1982

TO: All Faculty and Staff

FROM: John E. Van de Wetering

SUBJECT: Faculty-At-Large Meeting

 There will be an open meeting for faculty and staff on Tuesday,
June 29, 1982, at 4:00 p.m. in the College Union Ballroom.

 The purpose of the meeting will be to announce the faculty
reduction plan.

THE REALLOCATION PLAN. In the spring, the new president announced an administrative reorganization that melded six academic divisions into three schools and eliminated several highly placed administrators from the previous administration. At the same time, the Faculty Senate deliberated and then passed guidelines for reallocation, which the administration moved to implement. In late June, the president revealed his "faculty reduction plan," eliminating 50 teaching faculty, 37 of whom were tenured. These cuts aggravated the growing competition among departments and schools for limited resources. Even worse is that the cuts provided only temporary relief because the college continued to lose enrollment and SUNY budgets continued to be squeezed by the state.

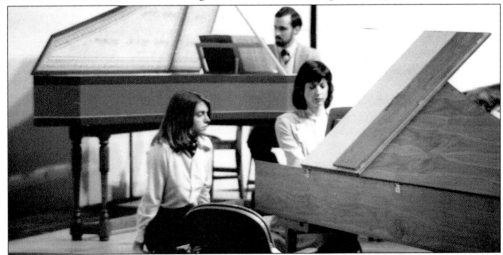

WHAT WE LOST. Although few could argue against the necessity of cuts somewhere, the losses of programs in music, botany, German, geography, and speech therapy, as well as the selective elimination of junior faculty in departments across the campus, were hotly debated. The annual Keyboard Festival, pictured here, along with the unique Keyboard Institute, was eliminated.

98

HONORS CONVOCATION, 1982. To ward off increasing despair, the college revived old traditions honoring excellence and introduced new ones. The Honors Convocation, originally created by Prof. Wayne Dedman in 1958, returned as a major event on the college's spring calendar, while greater attention was paid to nominating students for *Who's Who in American Colleges and Universities* and faculty members and professional staff for a host of awards, such as the Chancellor's Awards for Excellence in Teaching and Professional Service.

THE FIRST SCHOLAR'S DAY, 1984. In the spring of 1984, the Faculty Senate, strongly supported by Vice Pres. Robert M. Marcus, created a new rite of spring, Scholar's Day. Scheduled in advance, the day's classes were cancelled so students and faculty could present the results of their research or creative activity to the larger college community. The college, both administration and faculty, strongly supported the establishment of honorary societies such as Alpha Chi, the national honor society that inducted its first Brockport chapter members in 1986.

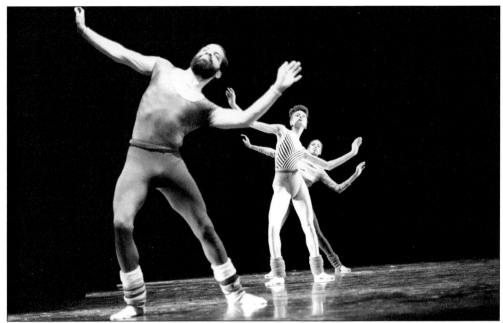

THE BUCKET DANCE COMPANY. In the 1970s, Prof. Garth Fagan recruited students into a performing company that he named the Bottom of the Bucket. In time, the name was shortened to simply the Bucket Dance Company. Its regional reputation secure, the company soon garnered praise from national critics.

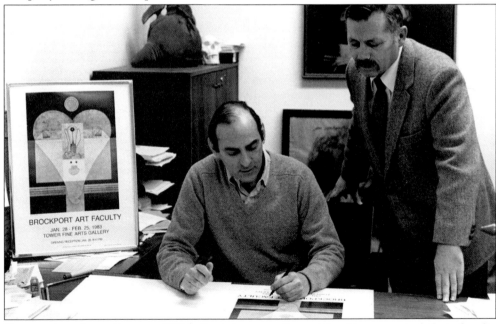

FACULTY ART SHOW, JANUARY 1984. Each January, the art faculty presented their faculty show in the Tower Fine Arts Gallery. And each year, this extraordinary group of artists reached broader audiences and received new appreciation. In this photograph, painters Mirko Pylyshenko (right), the department chair, and Jack Wolsky (left) examine the design of the show's poster.

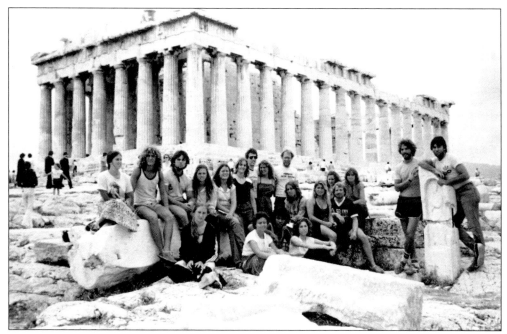

AT HOME ON THE ACROPOLIS. For many years, Brockport had sponsored international programs, most often courses conducted in the summer by interested faculty, such as Prof. Emanuel (Manny) Mouganis's annual trips to Greece. With the arrival of Donald Myers in 1968 and his subsequent appointment as director of international education, the international programs prospered, offering students the opportunity to spend semesters studying in another country. Under the leadership of Dr. John Perry, who succeeded Myers in 1980, the Office of International Education continued to grow in stature.

GRAPPLING FOR GLORY. While both football and men's basketball struggled through most of the decade, Brockport wrestlers under coach Don Murray earned a distinctive record of achievement, winning their first NCAA Division III national title in 1977, one of four titles over a seven-year span.

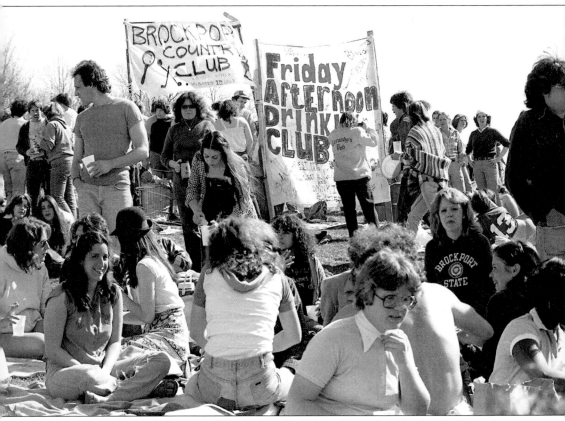

END OF AN ERA. In the spring of 1980, the administration moved Spring-In from the center of campus to its periphery, a field next to Stage XVI on the far edge of the campus. This would be the last of the annual beer blasts, symbolizing the end of the era.

Eight

THE COMPREHENSIVE
COLLEGE
1985–1996

In many ways, comprehensive colleges are often defined by what they are not: not professional schools, not liberal arts colleges, not research universities. They actually contain elements of all three, in varying degrees, based upon local tradition and current aspirations. Since the early 1970s, when Brockport added many professional programs, there had been a growing tension, heightened by the declining resources, between those departments and programs that defined themselves as liberal arts and those that defined themselves as professions.

Brockport was hardly unique in this regard, but these issues had greater currency on this campus than on most others. The term "comprehensive college" was coined to describe the complicated nature of such colleges, with their tradition of educating professional teachers, their recent emphasis on the liberal arts, and their newer professional and preprofessional programs.

Yet "comprehensive college" held little meaning for external audiences. Consequently, during the John Van de Wetering years, the college made several futile attempts to distinguish itself from other public colleges. At different times, it announced that it was a center for "mid-tech," declared "multi-culturalism" as the unifying theme of a Brockport education, and, finally, simply named itself "Rochester's Public University."

By 1990, the student body had increased in number while freshman SAT scores had moved up marginally. However, much of the enrollment increase came from part-time students at both the undergraduate and graduate levels. Part-timers doubled in this decade, making the college less of a traditional residential campus as it turned to serve more and more commuters. During this period, the college lost almost 1,000 on-campus residents, creating singles in rooms that had once been triples.

Budget problems were not solved, however, by the increasing enrollment because this was also the period of New York State's disinvestment in public higher education. State

support decreased from 90 percent of SUNY's operating budget in the mid-1980s to less than 40 percent a decade later, resulting in ongoing budget crises. Cost cutting became part of the college's annual task, and one solution was to substitute a large number of part-time instructors for retiring full-time faculty. Between 1984 and 1992, the number of adjunct faculty more than doubled. In February 1996, in response to yet another budget-slashing mandate from Albany, the administration cut the number of adjunct instructors by a third, generating savings of more than $300,000, while increasing the number of sections taught by full-time faculty, which proved to be exceedingly unpopular.

Despite the problems with annual operating budgets during the decade, SUNY campuses began to get funds to rehabilitate some of their older buildings. The first on the Brockport campus was Hartwell Hall, part of which had been closed in the mid-1980s, when the campus surrendered floor space to preserve personnel. The building was thoroughly rehabilitated in the early 1990s, and the administration next developed plans for Lennon Hall, the home of several natural science departments. Stage XVI, however, that award-winning residential complex for 1,000 students built on the campus's western border, could not be saved. Its 19 buildings were closed in stages, with the remaining structures being leveled in May 1992, 19 years after they opened but 16 years before the bonds would be paid off.

Even with the continuing financial problems that plagued public higher education in New York, the college achieved a degree of stability during this decade, maintaining its essential character as a comprehensive college. The student body included more transfer students than it had since the early 1970s, as well as more part-time and commuting students. It was more regional, and it included a much higher percentage of graduate students. Unchanged, however, was the fact that most students enrolled in programs that revolved around education certification, including physical education, which remained among the most popular programs on campus. In a sense, Brockport State Teachers College remained the core of what SUNY Brockport had become.

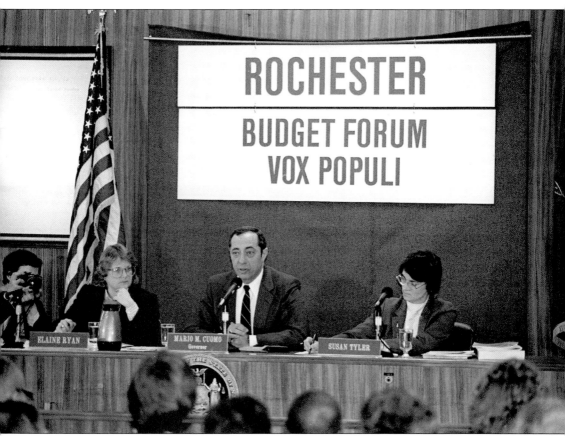

GOVERNOR CUOMO AND THE BUDGET. In the spring of 1985, Gov. Mario Cuomo toured the state to explain his budget priorities for the upcoming year, including a staged cut in state income taxes and greater flexibility for SUNY to manage its finances. Although frequently called a liberal on domestic social policy, Cuomo's budgets followed national trends and led to New York State's declining investment in public higher education.

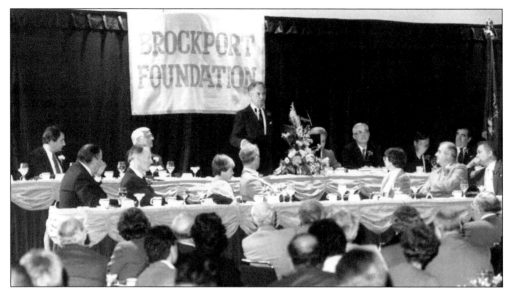

"The Campaign for Brockport, Rochester's Public University." As state funds failed to meet the college's needs, new sources were sought, in this case through a series of community dinners that recognized local leaders for their services to Monroe County and the region. In the picture below, Amb. Sol M. Linowitz, chairman of the board of Xerox before going to Washington, accepts the award in 1985. These dinners forged another tie between the Rochester community and the college as it proclaimed itself "Rochester's Public University." A decade later, the Brockport College Foundation conducted its first capital campaign. The foundation, like others throughout SUNY, came to private fund-raising late. It was created in the 1970s, after the prohibition on such organizations, as specified in the legislation establishing the state university in 1948, was lifted.

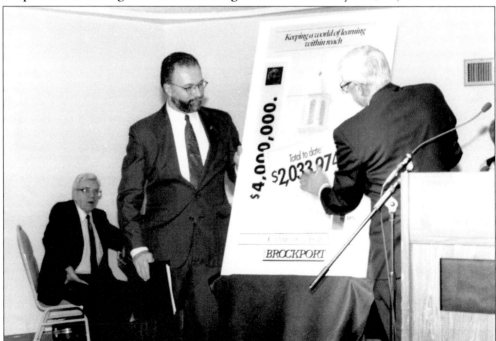

HIGH TECH. Higher education became much more expensive in the 1990s, as colleges and universities felt the fiscal impact of modern technology. The Rochester Area Interactive Televised Network (RAITN) room in Edwards Hall replaced the older one-way technology that had beamed programs to distant points. Interactivity changed the nature of mediated education, offering opportunities for genuine educational exchanges over long distances using both audio and video channels. It, like all means of distance learning, did so at a high cost. Colleges now regularly bought and updated computer equipment and software for student use. By 1995, the college had computer laboratories spread across the campus; creating the infrastructure for technology proved to be a budgetary burden.

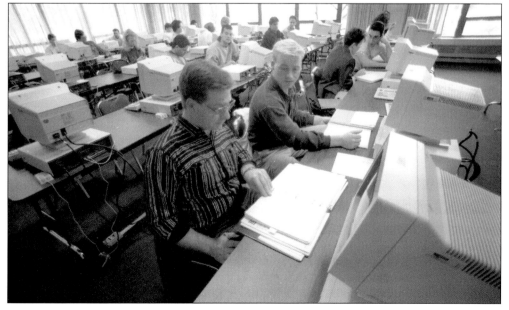

ROCHESTER EDUCATIONAL OPPORTUNITY CENTER. The college had allied itself to the city of Rochester (and the greater Monroe County region) in the late 1960s, despite its location 20 miles to the west of downtown. It actively sought working relationships with local corporations and schools; it even replaced Monroe Community College as the sponsoring agency for the Rochester Educational Opportunity Center (REOC) in 1973, becoming the only public college to administer one of New York State's 12 opportunity centers. At the REOC, students chose between a college preparation program and one that promised immediate employment, such as practical nursing. The center even ran a restaurant, Canopy's, that trained students in every aspect of food service.

METROCENTER. Many of the students enrolled at the REOC were adults, a segment of the population that the college specifically courted during the 1980s to help boost enrollments. The Office of Adult and Continuing Education offered convenient entry to higher education, with mall registrations, outreach to school districts and employers, and courses taught throughout the county. The downtown MetroCenter was only one of many sites where students could find SUNY Brockport.

BEST BUY. To attract traditionally aged undergraduates, especially in the early 1990s when enrollments once again began to drop, the college developed a short-lived Best Buy program that promised a four-year degree program through guaranteed access to necessary courses and no tuition increases. Beyond "best buy," the college emphasized its 30 graduate programs, many of which, like the master's degree in liberal studies, satisfied state requirements for "permanent" certification in education.

Campus Pride. Even the president pitched in (in full office attire) to help students move into their residence halls at the beginning of a semester. Walking behind is vice president for administrative services Maurice Kleiman. Move-in day eventually became something of a campus event, utilizing the energies of hundreds of student and staff volunteers. In the 1990s, students and faculty, organized by the buildings and grounds staff, lent a hand on Campus Pride Day, a Saturday morning when volunteers swarmed across the campus, planting flowers, pulling weeds, and picking up trash.

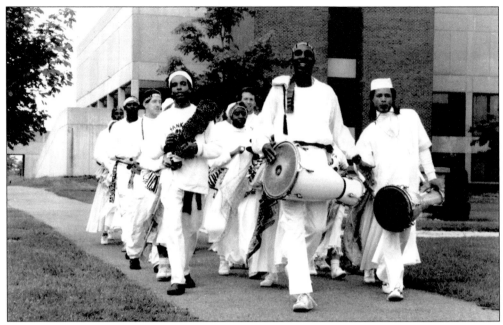

THE FINE ARTS. The fine arts continued to enrich Brockport campus life. Sankofa, a student African dance group led by Prof. Clyde Morgan, could be seen at many campus events, bringing life to academic ceremonies with its pulsating drums and challenging movements. Continuing a tradition that began in the early 1960s, the college hosted a summer arts festival, which included a summer musical, often deftly and playfully directed by Santo Giglio. Several of the pieces created by art professors joined the Special Olympics statues as works of public art that enriched the college's environment. In addition, student artwork filled the hallways of what became the Albert W. Brown Building. In the photograph below, William Stewart's large ceramic work is being installed on a wall of the Seymour College Union.

ATHLETICS. In 1986, Ed Matejkovic became the head football coach, an appointment that ultimately led to the creation of a stable, competitive program and the first playoff game in school history. In 1990, he assumed the responsibility of directing the intercollegiate athletic program, which fielded 23 varsity teams with more than 1,000 student athletes. When he returned to his alma mater five years later, he left behind a legacy of athletic excellence. In addition to the intercollegiate program, Brockport's intramural program serves thousands of students, with competitions ranging from broomball games late at night to softball tournaments on weekend afternoons.

THE OLD AND THE (RE)NEW. In 1992, Stage XVI met its final fate. The buildings had never stopped rusting, exterior walls developed large holes, and metal stairways weakened. The complex was dangerous and unusable. Rather than invest millions of dollars in residential space that was no longer needed, the college leveled the complex, even though the bonds that had been sold to pay for the original construction would not be amortized until 2008. At the same time plans were being laid for the demise of Stage XVI, the administration secured funding for the first major rehabilitation project of a major campus building, Hartwell Hall. A multimillion-dollar project, the reconstruction of the campus's signature building was an important step toward the future, creating exciting new spaces for classrooms, dance studios, and faculty offices.

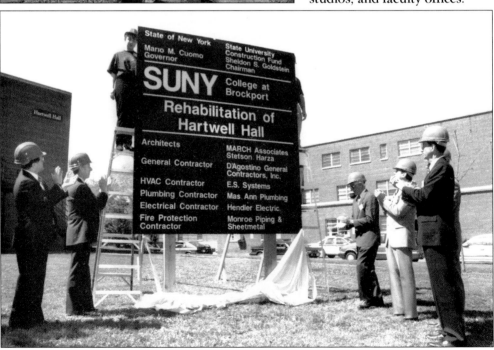

Nine

THE RETURN OF THE TRADITIONAL COLLEGE
1997–2006

At the 1996 fall convocation, Dr. John Van de Wetering announced his retirement, effective the following summer. The national search for his successor led to Dr. Paul Yu, the provost of Butler University. Upon arriving in early July, he faced a projected enrollment shortfall. President Yu quickly reorganized the administration, merging all admissions-related offices under a new vice president of enrollment management. The admissions office got a new director, increased expertise, and more resources. In addition, the new president invited broad participation in a campus-wide strategic planning process that generated support for a focused effort to recruit, retain, and graduate better prepared students, along with a phased reduction in the number of students entering as "special admits."

These policies signaled a major change. For two decades, the college's admissions had been weighted more heavily toward access than excellence. As a consequence, Brockport's incoming freshmen classes, as measured by standardized test scores and rank in class, were consistently in the lower third of SUNY colleges. To support the higher admissions standards, the administration created a very successful scholarship program.

The incoming freshmen classes improved, both in preparation and size. The college also recruited abroad and soon attracted an increasing number of talented students from overseas, especially eastern Europe. Delta College, the descendant of the Alternate College, and the College Honors Program particularly prospered in this new environment. But the adult undergraduate students, whom many faculty thought of as their best students in 1980s and 1990s, received less encouragement. The special programs that had eased their transition to the college disappeared, including the Office of Adult and Continuing Education.

Cultural and academic programming received greater emphasis. For example, the library's hours were extended, its new Aerie café provided a convenient space for study

breaks, and noontime concerts in the lobby provided musical interludes. Enhanced computer laboratories added new equipment and services as well as longer hours. Speakers, artistic performances, and athletic contests attracted growing numbers of students.

As Brockport told its story more effectively, its public image improved markedly. The campus's physical appearance improved as well. A new bridge over the railroad tracks eliminated an eyesore and a wintertime danger. And a new welcome center, with a mini-steeple echoing Hartwell Hall's, provided an attractive new first impression to visitors. Planning began for new residential apartments and a major convocation center, the first major construction on the campus in almost a quarter century.

Despite focusing on re-creating a residential campus of largely traditionally aged (18–21) students, the administration continued to reach out to the greater Rochester community, purchasing a permanent downtown site for the MetroCenter, and developing long-term relationships with the area's major cultural institutions, principally Geva, the acclaimed regional theater, and the renowned Rochester Philharmonic Orchestra. The latter proved especially worthwhile as it, and a revived Brockport Chorus, brought music back to the campus.

While students got younger, so did the faculty and staff. By the late 1990s, the college experienced the beginnings of a generational turnover. Many faculty and professional staff who had sustained the campus during the difficult preceding decades began to retire. When President Yu left in 2004, one-third of the faculty had been hired during his seven years at the helm.

Despite enrollment improvement, budgets remained a concern as state support for SUNY's annual operating budget dipped below 30 percent in the first decade of the new century. As students substituted tuition and loans for public dollars, some referred to SUNY as a "publicly supported" university rather than a public university. In addition, SUNY was governed by a new board of trustees, many of whom often appeared to be antagonistic toward public higher education in general, and SUNY in particular. In several instances, the board acted with little notice or consultation, as when it mandated a new general education program for every state-operated campus in the system.

Although a more highly bureaucratized university required voluminous assessment reports and strategic planning documents, most faculty and staff judged the time spent a small price to pay for the progress that had been made. The emphasis on better prepared students provided a focus that had been missing in recent decades. The skirmishes of decades past, between the Offices of Academic Affairs and Student Affairs, between the liberal arts and the professions, even among the faculty and staff and administration, abated, if not disappeared. To many, the college had achieved a welcome, even comfortable, maturity.

PRESIDENTS THREE. After an extensive national search, Dr. Paul Yu (center), a philosopher who had been provost of Butler University, became the college's fifth president in July 1997. Here he is pictured with his two immediate predecessors, Albert W. Brown (right) and John Van de Wetering (left), at his inauguration in October 1998. The inaugural events celebrated the college's rich heritage, with dance recitals, faculty presentations, student panels, and the rededication of Hartwell Hall.

A NEW TEAM. Pres. Paul Yu soon selected Dr. Timothy Flanagan (right), who had experience in SUNY before becoming dean of the School of Criminal Justice at Sam Houston State, as his academic vice president, and Raymond DiPasquale as vice president for enrollment management. They helped form an administrative team that gave the college great stability over the next eight years. Both left the campus for college presidencies in 2006.

NEW ADVERTISEMENTS. Vice President DiPasquale's portfolio included both admissions and college relations, which helped design new advertising campaigns that used the motto Expect the Extraordinary. That phrase, along with the new mission statement assertion that student success was the college's first priority, was among those most frequently heard over the next several years. During the first strategic planning process, President Yu invited broad campus participation in addressing six areas of concern. While each was important, the question of which students the college would teach became the galvanizing issue. The college's new commitment to rising measures of student quality paralleled changes in SUNY administration. For the first time since the late 1960s, SUNY Brockport's ambitions clearly mirrored those of the university's central administration.

COLLEGE HONORS PROGRAM AND
DELTA COLLEGE. The College Honors
Program and Delta College were
specific beneficiaries of the initiative
for better prepared students. After
each program suffered something
close to a near-death experience
in the 1990s, they now received
renewed support, new leadership,
and a significantly larger pool of
qualified incoming freshmen to
whom the programs would naturally
appeal. In these photographs, Delta
students are examining a sand
mandala that was created for their
annual World Conference. On the
other hand, students in the Honors
Program, one of the largest in SUNY,
are enjoying a late-spring break just
before final exams week. By 2004,
these programs, which featured
small classes, had developed
learning communities that supported
student achievement in all areas of
college life.

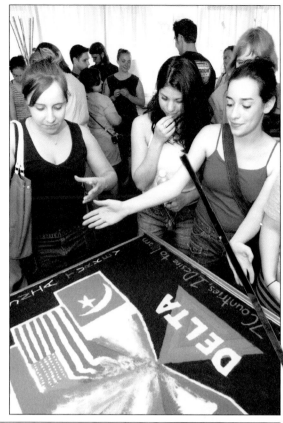

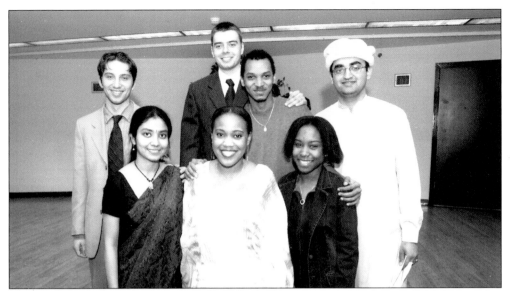

INTERNATIONAL STUDENTS. Attracting a larger number of international students was another initiative identified in the first strategic planning process. Through the first years of the new century, the number of international students grew slowly, but significantly, and an office was created to manage the attendant issues for students from abroad, especially after September 11, 2001, when the rules for foreign students became more complex. In addition, larger numbers of Brockport's students began taking advantage of the college's extensive international study programs.

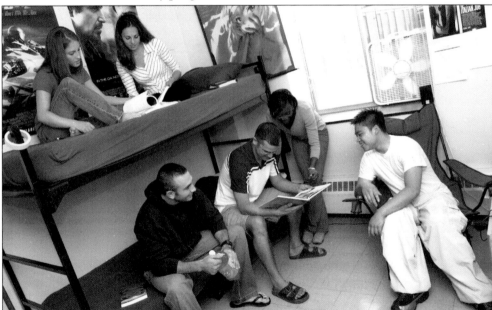

HOME AWAY FROM HOME. The Residential Life program in the late 1990s became more focused on supporting learning communities in residence halls. In 1998, five faculty-in-residence positions were offered to younger faculty, moving them into the residence halls to foster living-learning environments. A series of major renovations of college residence halls began modernizing facilities in their fourth decade of service.

UNION SQUARE. With increasing numbers of students living on campus, the on-campus facilities that serve a residential population were upgraded, in this case, Union Square, the on-campus snack bar in Seymour College Union. After its thorough renovation, the union offered students a specialized coffee shop, the campus bookstore, offices for student organizations, lounges, and a computer laboratory.

WORKING OUT. Today's students expect services that did not exist 10 years before. The students in this photograph are using one of two exercise rooms that the college has created, but note that several are watching a television and another is reading a book, while the student in the foreground is listening to music. In the 1990s, the residence halls were wired for television cable; a decade later fiber optics connected computers to the outside world; today the campus is wireless. Together with cellular technology, these technologies allow students to reach anyone or any site at any time.

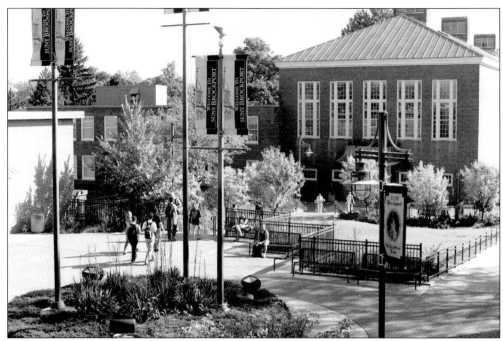

PASSAGES. In the 1990s, the administration tackled a long-standing pedestrian traffic problem: the need to walk around Lathrop, Neff, and Morgan Halls to reach Hartwell Hall. The solution? Tear down Neff and replace it with a plaza. Another problem area was the uncovered bridge that crossed the railroad tracks and connected the central part of the campus with Drake Library and Allen Administration Building. It worked well until the snows fell, and snow does fall in Brockport between November and April. This hazard was finally ended when the bridge was replaced by a graceful covered structure, which was later joined by a second bridge connecting the library to the Tuttle athletic complex.

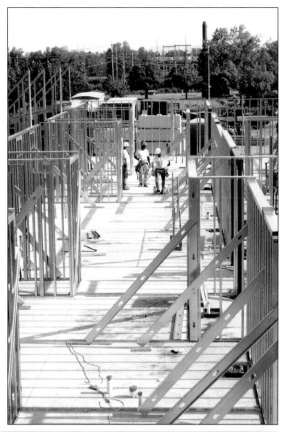

NEW BUILDING. For the first time since the mid-1990s, the college planned for new buildings. The Raye Conrad Welcome Center greets visitors at the gateway to the campus, and construction on a uniquely financed townhouse complex has begun. Apartment-style residence hall living, popular on many other campuses, had been missing at Brockport since the demolition of Stage XVI. Planning has also begun for a $30 million special events and recreation center, which will be added to the Tuttle complex, giving the campus an indoor track, as well as a space for major concerts and commencements.

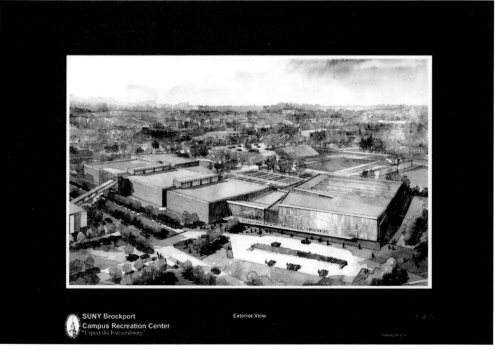

SUNY Brockport
Campus Recreation Center
"Expect the Extraordinary" Exterior View

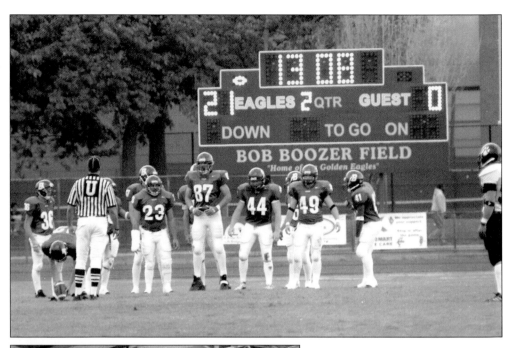

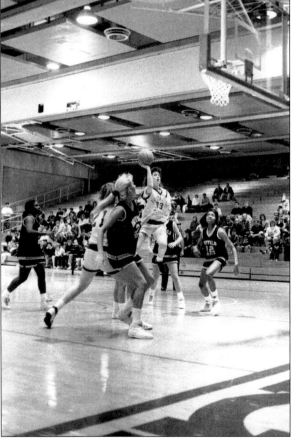

IMPROVED ATHLETICS. In the last decade, the athletic program excelled. The leadership of Ed Matjekovic and his successor, Linda Case, created a stable environment that values athletic success within the context of NCAA Division III restrictions and within a college that was raising its admissions standards. The result has been a program that wins both on the field and off. Gender equity has been largely achieved, despite the costs entailed and number of players involved in football. That program earned remarkable success in the first half decade of the new century, becoming a power in the eastern region, as it won 26 of 31 games in the 2000, 2001, and 2002 seasons.

THE NEW PRESIDENT. In spring 2004, Pres. Paul Yu, after seven successful years at the college, accepted the presidency at California State University at San Jose. During the 2004–2005 academic year, the colorful Dr. John B. Clark ably served as interim president. In spring 2005, Dr. John R. Halstead, the president at Mansfield University of Pennsylvania, accepted the offer to become SUNY Brockport's sixth president. Above, Dr. Halstead is pictured with two of his predecessors, John Van de Wetering and Albert W. Brown. Below, he is sharing a lit candle with one of the new generation of faculty members, Dr. Donna Kowal (Department of Communication), at the ceremony that welcomes new students to the Brockport college community.

"The Future's So Bright." In the words of Timbuk 3, "I'm doing all right, getting good grades, the future's so bright, I gotta wear shades." While these students do not need sunglasses, they do have bright futures. They represent the tens of thousands of students who have come—and who will come—to this college seeking an education for a better, more well-informed life.

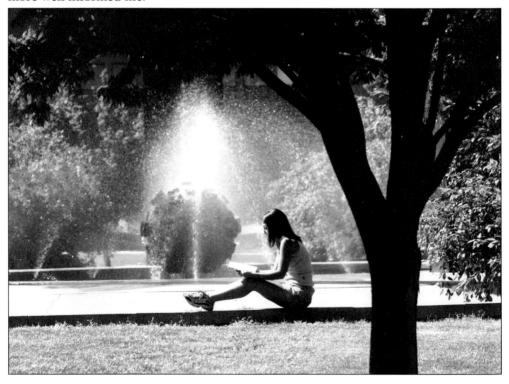

REFLECTIONS

Today's SUNY Brockport is the result of the work of faculty, staff, and students over more than 170 years. Its mission has frequently changed, often in ways that would impress, or perplex, those who went before.

Its evolution often reflected national, even international, trends. As a frontier college born of local and denominational initiative, it repeated a uniquely American approach to higher education. As a normal school, it adopted a model influenced by French and German practice. The transformation into a state teachers college belatedly followed a national trend.

On the other hand, any college reflects its own unique community, both on its campus and beyond. For a century, a local board of trustees put its stamp on the institution. Through the 1960s, most students hailed from western New York, lived with local families, and participated in the life of a village on the Erie Canal, giving the institution a large part of its character.

But Brockport also had its turn in the national spotlight, when Pres. Albert W. Brown, strongly supported by SUNY chancellor Samuel B. Gould, created a national model for transforming teachers colleges into multipurpose institutions. A decade of expansion, when everything seemed possible, fueled imaginations and generated new programmatic ideas that sent the college far beyond the boundaries of its campus.

Among state colleges, Brockport's star rose faster than most. And when local, state, and national trends reversed, it fell more precipitously. Two decades of institutional angst and loss of direction eventually yielded a college that had achieved stability and that was comfortable with itself. That solution took the college back to the future, with a reemphasis upon residential undergraduate life for a traditional college-age population. Yet Brockport maintained many other facets inherited from the experimentation of the previous decades, including a large graduate program, continuing commitment to mature students, and a major urban center.

While each generation makes its own history, in so doing it has been shaped by circumstances inherited from the past. This book closes with the hope that this exploration of SUNY Brockport's history provides the college community with a shared sense of the traditions that have determined its past, and in so doing, helps inform the college's future.

www.arcadiapublishing.com

Discover books about the town where you grew up, the cities where your friends and families live, the town where your parents met, or even that retirement spot you've been dreaming about. Our Web site provides history lovers with exclusive deals, advanced notification about new titles, e-mail alerts of author events, and much more.

MADE IN THE USA

Arcadia Publishing, the leading local history publisher in the United States, is committed to making history accessible and meaningful through publishing books that celebrate and preserve the heritage of America's people and places. Consistent with our mission to preserve history on a local level, this book was printed in South Carolina on American-made paper and manufactured entirely in the United States.

This book carries the accredited Forest Stewardship Council (FSC) label and is printed on 100 percent FSC-certified paper. Products carrying the FSC label are independently certified to assure consumers that they come from forests that are managed to meet the social, economic, and ecological needs of present and future generations.

FSC
Mixed Sources
Product group from well-managed forests and other controlled sources

Cert no. SW-COC-001530
www.fsc.org
© 1996 Forest Stewardship Council

Find Your Place in History.